02/02

FORESTS AND WOODLANDS

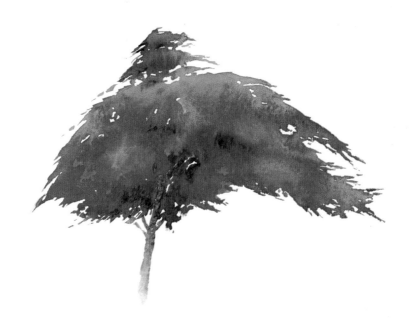

RICHARD TAYLOR

C&B

COLLINS & BROWN

D1087170

First published in Great Britain in 2001 by
Collins & Brown Limited
London House
Great Eastern Wharf
Parkgate Road
London SW11 4NQ

Distributed in the United States and Canada by Sterling Publishing Co., 387 Park Avenue
South, New York, NY 10016, USA

Copyright © Collins & Brown Limited 2001
Text copyright © Richard Taylor 2001
Illustration copyright © Richard Taylor 2001

The right of Richard Taylor to be identified as the author of this work has been asserted
by him in accordance with the Copyright, Designs and Patents Act, 1988.

All rights reserved. No part of this publication may be reproduced, stored in a retrieval
system, or transmitted in any form or by any means, electronic, mechanical,
photocopying, recording or otherwise, without the prior written permission of the
copyright owner.

3 5 7 9 8 6 4 2

British Library Cataloguing-in-Publication Data:
A catalogue record for this book
is available from the British Library.

ISBN 1 85585 842 8

Editor: Ian Kearey
Designer: Alison Shackleton
Photography: George Taylor

Reproduction by Classicscan, Singapore
Printed and bound in Singapore by Tat Wei

This book was typeset using Rotis Sans Serif.

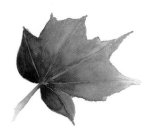

CONTENTS

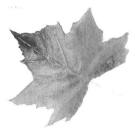

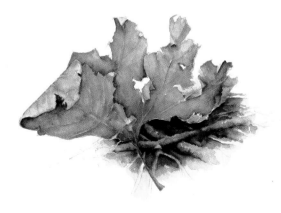

Tools and Materials

Because this book is intended primarily as a 'field guide' that you can take on painting expeditions out into the forests and woodlands, this chapter looks at some of the tools and materials that I find most useful to work with outdoors.

To start with paper, I find that watercolour sketchpads are the most useful form of ground – especially the ringbound versions, which give you a hard-backed surface to work on. These sketchpads are available in a wide range of types and sizes – my personal preference is for a 210 x 297mm (8^1/$_4$ x 11^3/$_4$in) or 297 x 420mm (11^3/$_4$ x 16^1/$_2$ in) pad with at least 300 gsm weight watercolour paper, because this allows me to 'throw' some water at the paper in the knowledge that it will stay reasonably flat and not cockle.

I also carry a small pocket-size drawing paper pad for making quick pencil sketches – these sketches allow me to make notes of the basic structure (both linear and tonal) of my subject prior to making a finished painting.

Sketching in monochrome can often be a valuable way of sorting out the tonal values of your subject without getting too involved with colour at an early stage.

Various tools are available for drawing in monochrome: graphite, or sketching, pencils are the main ones and are certainly the most useful to carry in your sketching bag.

Leaf studies are useful before making a painting – they allow you to concentrate on the colour and tone of the leaf.

PADS AND SKETCHBOOKS

Watercolour and drawing paper pads are essential for outdoor use, because they are compact and allow you to keep all of your work flat and held together. They can be used for visual notes to remind you of the scene, and personal thoughts, as well as for more 'finished' paintings.

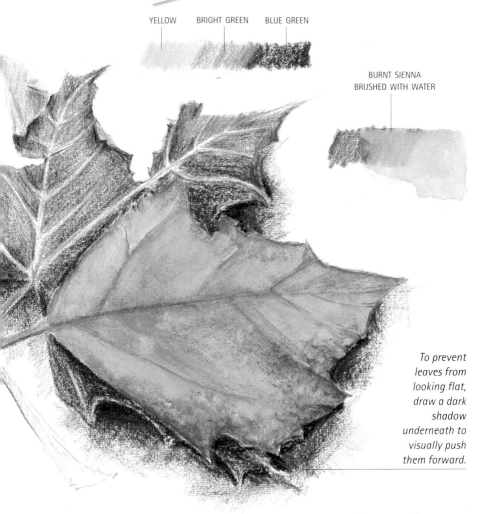

YELLOW BRIGHT GREEN BLUE GREEN

BURNT SIENNA
BRUSHED WITH WATER

To prevent leaves from looking flat, draw a dark shadow underneath to visually push them forward.

Graphite pencils can be divided into two categories – standard drawing pencils and water-soluble pencils. Standard drawing pencils are readily available and come in a wide range of grades, with B being the hardest grade used by most artists, and 6B the softest for practical use.

Sketching pencils are very soft graphite pencils with thick leads, and are good for making quick, bold sketches.

Water-soluble pencils make a normal graphite mark, but the mark can be washed over with water to produce a soft, water-colour-type grey tone. Water-soluble pencils are available in different grades, although these are usually limited to soft, medium and hard.

The advantages of tonal sketching are many. First, if you squint, half-closing your eyes, you see a simplified, tonal version of your subject. Recording these tones will help you to see where the dark, medium and light areas of your composition are before you make a commitment to paint. Second, you can draw or sketch onto any type of paper – even water-soluble pencils

Travelling Light

A few selected pencils are a valuable asset to your sketching kit – carrying too many only complicates matters, as you have to think about which ones to use. Graphite pencils come in a variety of grades. Artists usually make use of the B (soft) grade pencils: 6B is the softest and gives rich, dark tones, while B is the lightest and offers a subtle range of greys.

B

2B

4B

6B

Combining Media

Water-soluble coloured pencils are useful tools for studying colour, and can easily be used in conjunction with watercolour paints.

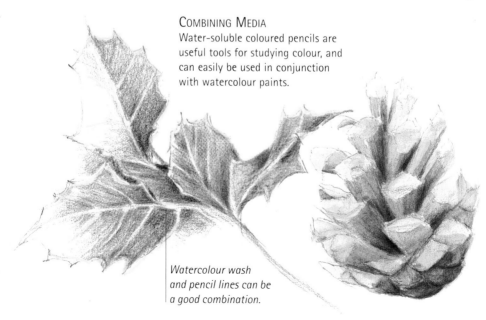

Watercolour wash and pencil lines can be a good combination.

can be used easily on drawing paper. Third, you can carry a pencil and a small pad with you wherever you go.

When drawing and sketching, practise holding your pencil in two different ways. To sketch a quick outline, hold your pencil as you would for writing, and draw with the tip. However, when you want to block in or shade an area, change your grip and place your finger along the shaft of the pencil so that you draw with the edge of the lead. Each style of drawing serves different purposes and is worth mastering.

Sometimes it is a good idea to make a few 'visual notes' using colour pencils to capture the nature of your subject, the colour, shape and structure for example, especially when you are short of time or when a scene is changing rapidly.

Standard coloured pencils are highly effective tools for making colour sketches. They are available in a large range of colours, but I strongly suggest that you restrict yourself to a set of no more than seven: deep green, sap green, olive green, yellow, raw sienna, burnt umber and ultramarine.

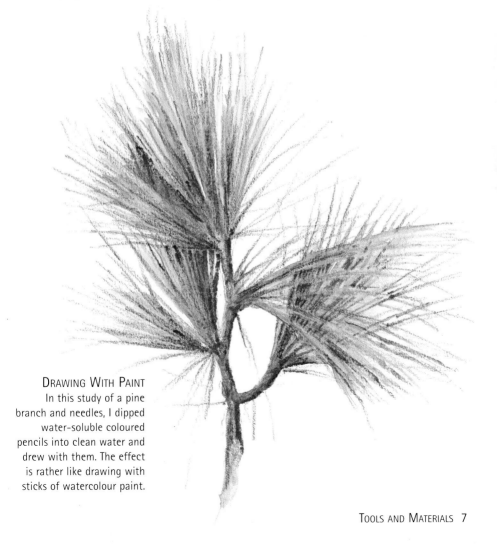

DRAWING WITH PAINT
In this study of a pine branch and needles, I dipped water-soluble coloured pencils into clean water and drew with them. The effect is rather like drawing with sticks of watercolour paint.

Water-soluble colour pencils are much softer than standard coloured pencils, being solidified sticks of watercolour pigment, and create a series of highly textured marks when used on watercolour paper. They are, however, most effective when washed over with water, turning the pigment into watercolour paint. They can also be dipped into water and used to draw onto painted areas, darkening the appropriate sections – again, practise and experiment to find the method of working that suits you best.

A small watercolour tin that holds pan paints fits easily into a pocket, and I can fit in any colour pans that I choose. These tins often come with a retractable brush, and more elaborate versions sometimes have a small water container built in as well. I use one large wash brush, one medium, and one small detail brush (all round-headed), plus one flat-headed or chisel brush.

All these items are kept in a strong canvas backpack that can withstand being sat on and thrown over hedges and gates.

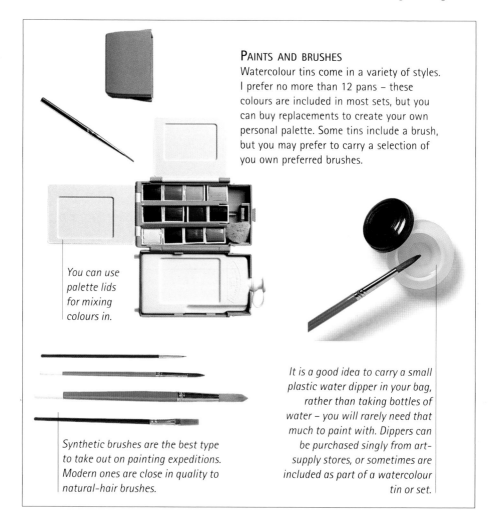

PAINTS AND BRUSHES
Watercolour tins come in a variety of styles. I prefer no more than 12 pans – these colours are included in most sets, but you can buy replacements to create your own personal palette. Some tins include a brush, but you may prefer to carry a selection of you own preferred brushes.

You can use palette lids for mixing colours in.

Synthetic brushes are the best type to take out on painting expeditions. Modern ones are close in quality to natural-hair brushes.

It is a good idea to carry a small plastic water dipper in your bag, rather than taking bottles of water – you will rarely need that much to paint with. Dippers can be purchased singly from art-supply stores, or sometimes are included as part of a watercolour tin or set.

FROM SKETCHES TO PAINTINGS

The wealth of colours that can be found in any woodland scene deserves close observation and study. This is often best done by making a few quick sketches using water-soluble coloured pencils for speed, and then subsequently combining these with watercolour paints to capture subtle effects and tones.

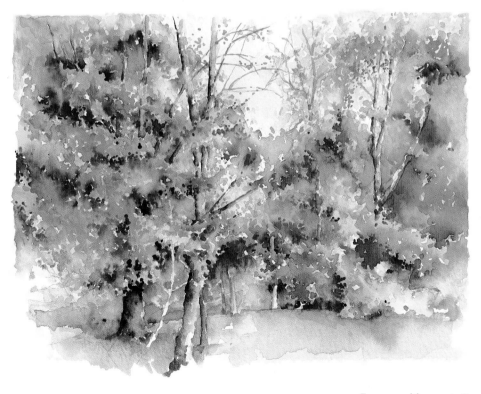

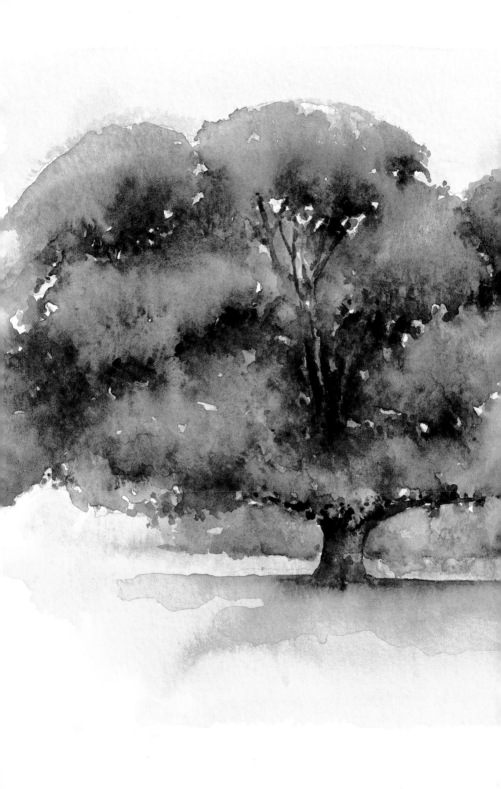

TREE AND LEAF SHAPES

Most objects can be reduced to a basic geometric shape – and trees, although irregular in shape, are particularly suited to this technique. While some trees defy simplification, most can be categorized into four main shapes: round-topped trees, tall thin trees, conical trees (conifers) and flat-topped trees. This creates a framework within which you can develop the more specific shape of the tree that you are painting.

ROUND-TOPPED TREES

One of the key characteristics of round-topped trees is that the branches and foliage usually take up approximately two-thirds of the height of the tree, leaving only a small trunk showing. Oaks, walnuts and horse chestnuts all fall into this category.

If you are painting round-topped trees in spring or winter, load a small brush with paint and begin at the main branch. Then pull the brush outwards, easing off the pressure until only the tip of the brush is touching the paper as the branches taper outwards, ending with a mass of fine, pointed twigs. During the summer months, however, the foliage covers the branches in a heavy dome, creating areas of shadow in the central sections as well as at the bottom of the tree. These sections are best painted when the initial underwash (usually a mixture of raw sienna and sap green) is still damp: mix and 'touch in' the darker tones once the surface water has evaporated.

Although you may not be able to see the branches when the trees are fully covered with masses of leaves, try to imagine where the main boughs and branches are. The branches support the leaves, and knowing where they are will help you to work out the main areas of light and shade – light above the branches, shadow below them.

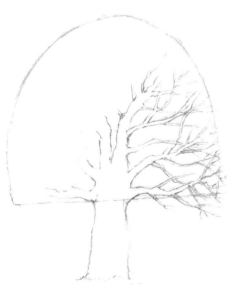

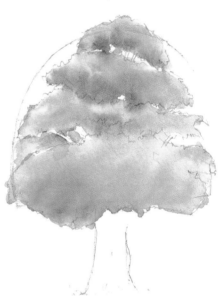

BASIC STRUCTURE
Most round-topped trees fit into a dome-type shape. One of the key characteristics of this kind of tree is that in summer the foliage takes up more than half the height of the tree, so make sure that you do not draw the straight base line high up the trunk.

FIRST WASHES
As soon as the first wash of paint has been applied to the mass of foliage on the tree, mix a darker version of the chosen green by adding blues and browns to the first wash. Touch this into the damp paper to visually divide the bulk of the foliage.

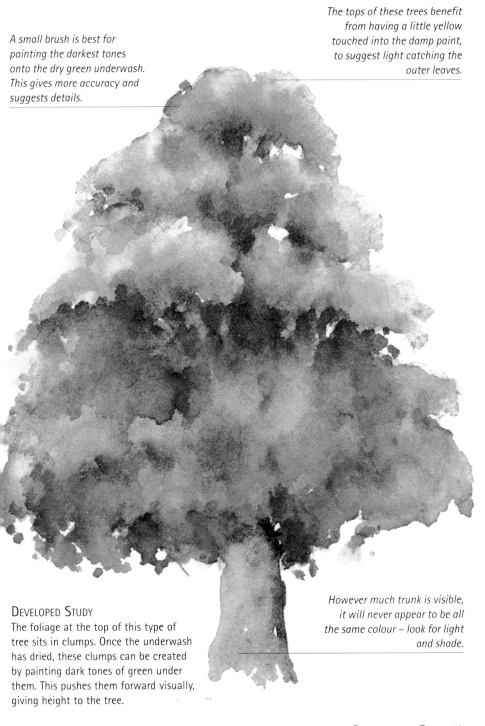

A small brush is best for painting the darkest tones onto the dry green underwash. This gives more accuracy and suggests details.

The tops of these trees benefit from having a little yellow touched into the damp paint, to suggest light catching the outer leaves.

DEVELOPED STUDY
The foliage at the top of this type of tree sits in clumps. Once the underwash has dried, these clumps can be created by painting dark tones of green under them. This pushes them forward visually, giving height to the tree.

However much trunk is visible, it will never appear to be all the same colour – look for light and shade.

When painting round-topped trees, it is best to start applying paint at the top and work towards the bottom. If you angle your paper downwards a little, the paint will run gently (if applied to damp paper), leaving the highlights at the top of the tree and the bulk of the heavy toning closer to the wider bottoms.

The stronger your basic mix, the darker the shading at the base of the tree will be. Judge the mood of the day and the lighting that falls on the tree which you are painting before committing to paper. If, however, your paint does begin to dry too dark, you can always blot some out with a piece of kitchen roll.

A CLASSIC EXAMPLE
Over the years this grand old oak tree had grown into a nearly perfect dome shape, making it very easy for me to define and start painting it.

LETTING PAINT BLEED
Round-topped trees are best painted onto damp paper, applying the darkest paint to the shaded areas and allowing it to bleed slightly. This is a different technique to 'wet-into-wet' (see page 30), as the paper only needs to be dampened. One medium brush is used to wash the colours on, and one small brush to apply the shadows.

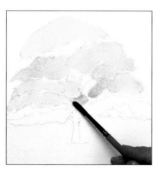

1 *Wash the undercoat or base colour across the tree in a sweeping, even motion.*

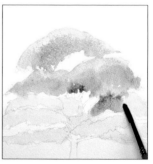

2 *As this begins to dry, apply small touches of the shadow tone using a small brush.*

Sometimes the darkest colours are at the outer edges of leaves. Work onto damp paper and allow these colours to blend into the centre.

SHAPE AND COLOUR

Oak leaves are usually at their most visually interesting at the beginning of the autumn, just as the greens start to turn yellow, then finally to brown. The most dramatic colour changes occur at the edges of the leaves, and can be used to help define their shape.

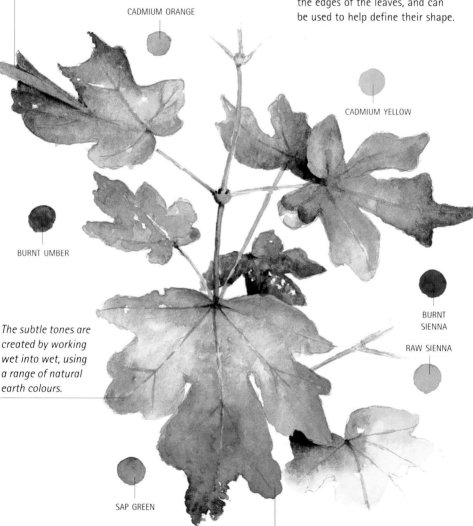

CADMIUM ORANGE

CADMIUM YELLOW

BURNT UMBER

BURNT SIENNA

RAW SIENNA

The subtle tones are created by working wet into wet, using a range of natural earth colours.

SAP GREEN

Look carefully at the veins in a leaf. Do they appear darker or lighter than the leaf itself? Always check.

ROUND-TOPPED TREES 15

TALL THIN TREES

Trees that fit into this category include poplars, birches and plane trees. These are best constructed by drawing a long, tall and thin oval shape with a small area of trunk at the base (this will often be less than the trunk of round-topped trees). The length of these trees usually allows the clumps of foliage to be a little more spaced out, with more trunk and branches visible.

Because the boughs and branches are shorter and stronger than those of round-topped trees, the weight of the leaves, particularly in the summer, does not put so much pressure on the boughs at their outer extremities. For the painter, this means that you can find less extremes of light and shade, and more dominant middle tones – usually the colours of the underwash – on the outer edges of the bulk of the tree.

Tall thin trees often have gaps between the clumps of leaves, with either sky or other trees being visible through the spaces. The best way to create these gaps is to 'draw' around several blank areas of paper when applying the initial wash of water to dampen the paper, rather than soaking the entire bulk of the tree: water does not flow onto dry paper readily, so when you apply the underwash, the undampened areas will remain free of paint.

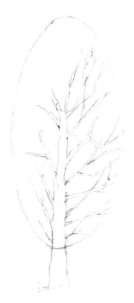

BASIC STRUCTURE
A wide variety of tree types fall into the 'tall thin' category, but they are all best recorded within an upright oval shape, as in this sketch. The foliage usually takes up at least two-thirds of the height of the tree.

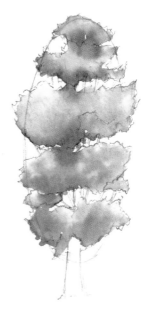

FIRST WASHES
It is easy to observe the layers of foliage in these tall thin trees, and to see that they are visually divided by tone. Wait until the basic colour wash is barely damp, then touch in the shadow colour – this will bleed a little, producing some natural blends.

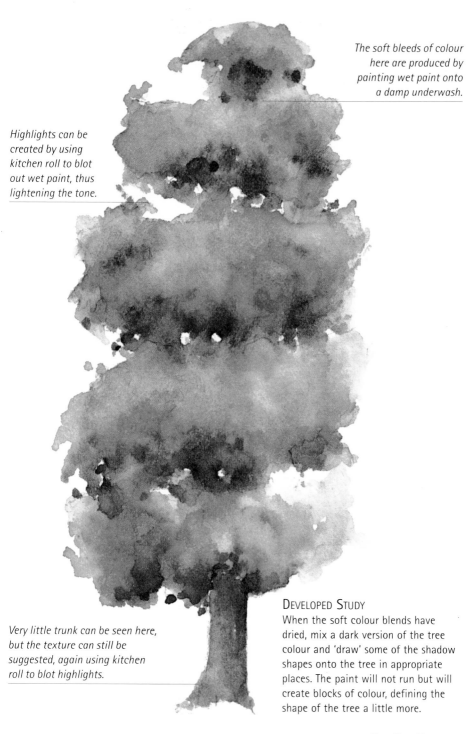

The soft bleeds of colour here are produced by painting wet paint onto a damp underwash.

Highlights can be created by using kitchen roll to blot out wet paint, thus lightening the tone.

Very little trunk can be seen here, but the texture can still be suggested, again using kitchen roll to blot highlights.

DEVELOPED STUDY

When the soft colour blends have dried, mix a dark version of the tree colour and 'draw' some of the shadow shapes onto the tree in appropriate places. The paint will not run but will create blocks of colour, defining the shape of the tree a little more.

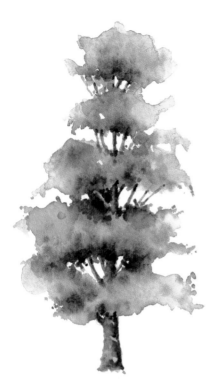

The clumps of foliage of tall trees such as planes are divided by both space and tone. Gaps are often clearly visible between the layers of foliage, while the less subtle divisions between leaf colours can be emphasized by adding a darker tone.

To create this effect, add a darker version of the basic tree mix (sap green, raw sienna and burnt umber were used on the picture to the left) to the base of the layers of foliage while they are still damp, enabling the paint to spread and dry without a visible water mark. Next, add the branches using a small brush and a mixture of burnt umber and ultramarine.

The grace and elegance of these tall trees can be created by this use of dark and light, but particularly by close observation of the spaces in between the sharply angled branches and the foliage that they support.

PLANE TREE
The foliage on this tree was established by painting the different coloured sections individually, then allowing them to bleed together in certain parts.

LIGHT VEINS ON DARKER LEAVES
Rendering veins in leaves involves creating an overall underwash: first by painting the basic colour onto wet paper using a large or medium brush, then adding more colour onto dry paper using a medium or small brush. The final stage is drawing onto the leaf with very little paint.

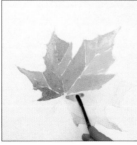

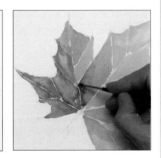

1 *First wash the basic colour onto wet paper. The colour formed as it dries will form the basic colour of the vein.*

2 *When dry, use a medium brush to paint around the lines of the veins, leaving a web of negative shapes.*

3 *Use a small brush to paint a dark line of the basic leaf mix along the vein edges – the paint bleeds away from the veins.*

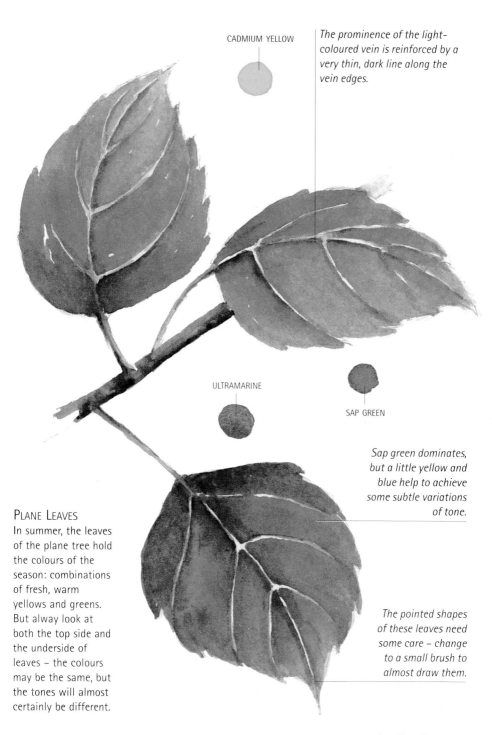

CADMIUM YELLOW

The prominence of the light-coloured vein is reinforced by a very thin, dark line along the vein edges.

ULTRAMARINE

SAP GREEN

Sap green dominates, but a little yellow and blue help to achieve some subtle variations of tone.

PLANE LEAVES
In summer, the leaves of the plane tree hold the colours of the season: combinations of fresh, warm yellows and greens. But alway look at both the top side and the underside of leaves – the colours may be the same, but the tones will almost certainly be different.

The pointed shapes of these leaves need some care – change to a small brush to almost draw them.

CONICAL TREES

Most conifer trees can be drawn to fit into a tall conical shape, leaving only a small amount of trunk showing at the base of the tree. Conifers are usually very 'full' trees that have few gaps showing between the branches (although the taller spruce members of the family are wider spread), so a lot of tonal variations are required in order to break up the mass of deep green foliage and avoid ending up with a solid mass.

A combination of three brushes is best for painting conifers – a large wash brush, a flat-headed or chisel brush, and a small detail brush. The large wash brush is invaluable for dampening paper prior to applying the first wash of paint. The flat-headed or chisel brush is used for applying the paint and exercising some control over its direction, using a sweeping motion to follow the shapes created by conifer branches and foliage. Finally, the small detail brush is best for finishing off areas of shadow, applying the paint with care to the darkest sections of the tree.

Conifers are ideal trees for exercising control over your painting as they hold many small areas of shaded detail.

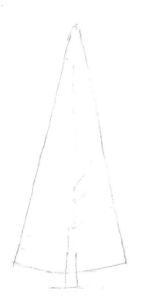

BASIC STRUCTURE
Most conifers, such as fir trees and the many varieties of pine trees, can be fitted into a conical shape in a preliminary sketch. Compared with the other basic tree shapes, conifers have very little of their trunk showing at the base.

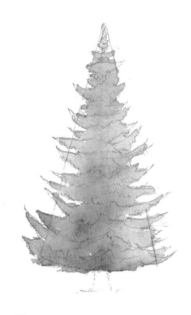

FIRST WASHES
Use a flat-headed or chisel brush to wash the base colour onto the conical shape, and paint using a sweeping, side-to-side action. The sharp, flat edge allows you to 'pull' the paint outwards, recreating the sharp edges of the tree.

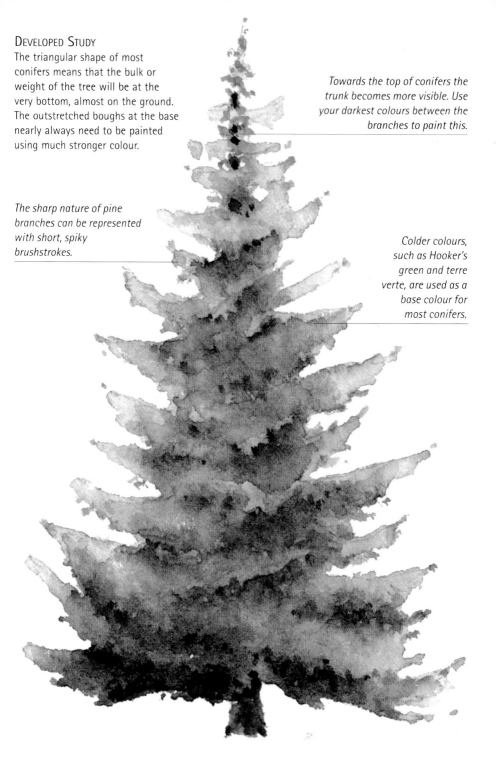

DEVELOPED STUDY

The triangular shape of most conifers means that the bulk or weight of the tree will be at the very bottom, almost on the ground. The outstretched boughs at the base nearly always need to be painted using much stronger colour.

Towards the top of conifers the trunk becomes more visible. Use your darkest colours between the branches to paint this.

The sharp nature of pine branches can be represented with short, spiky brushstrokes.

Colder colours, such as Hooker's green and terre verte, are used as a base colour for most conifers.

One common feature of some types of conifer tree is that you can often see much of the tree trunk – even in summer. This is particularly true of tall spruce trees. Although the foliage still fits into a triangular or conical shape, this shape often begins at least halfway up the tree rather than at the base, which is the case with other conifers.

Conifers vary from other trees in that they do not have 'leaves' in the way that we traditionally understand the term. The pine cones and needles on the branches and boughs need a different type of treatment altogether. Instead of allowing the colours to blend and bleed naturally, the needles have to be painted in a more 'graphic' style. To create single needles, flick a small brush outwards, creating thin lines, and use a wide variety of greens to prevent the study from looking like a flat block of colour.

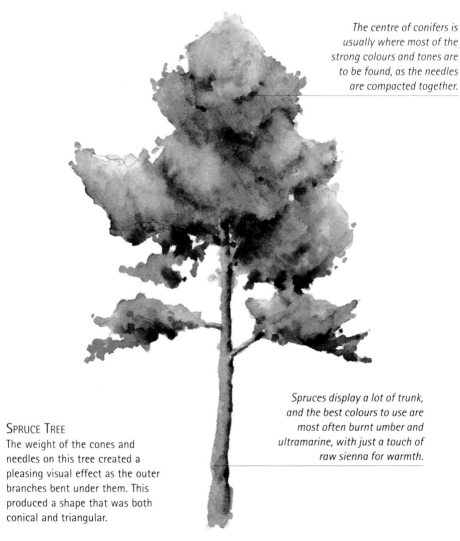

The centre of conifers is usually where most of the strong colours and tones are to be found, as the needles are compacted together.

Spruces display a lot of trunk, and the best colours to use are most often burnt umber and ultramarine, with just a touch of raw sienna for warmth.

SPRUCE TREE
The weight of the cones and needles on this tree created a pleasing visual effect as the outer branches bent under them. This produced a shape that was both conical and triangular.

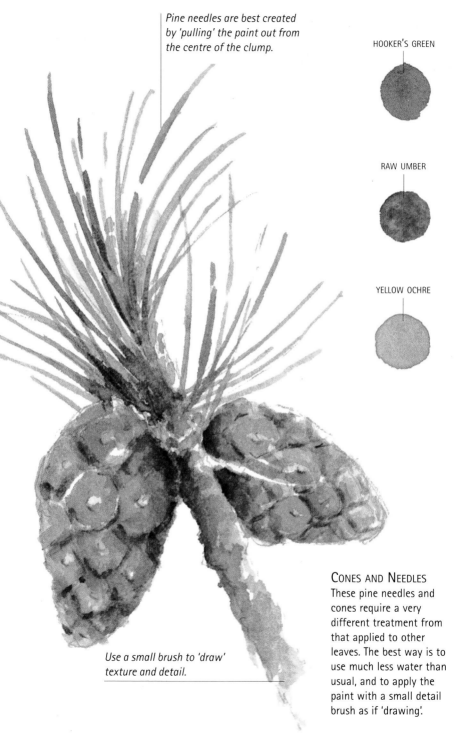

Pine needles are best created by 'pulling' the paint out from the centre of the clump.

HOOKER'S GREEN

RAW UMBER

YELLOW OCHRE

Use a small brush to 'draw' texture and detail.

CONES AND NEEDLES

These pine needles and cones require a very different treatment from that applied to other leaves. The best way is to use much less water than usual, and to apply the paint with a small detail brush as if 'drawing'.

FLAT-TOPPED TREES

Unlike the more regular round-topped trees or conifers, the *Acer* (maple) family of trees and Scots pines tend to have an uneven distribution of branches and leaves, with predominantly 'flat' tops (as opposed to domes, cones or points). These trees are best painted with a flat-headed or chisel brush, which allows you to pull the paint across the paper along the line of the foliage, maintaining a flat-topped or flat-bottomed line of paint, depending on the species and particular tree that you are painting.

In many cases, years of exposure to strong prevailing winds results in the vast majority of a tree's growth being on one side only, and the initial appearance is of

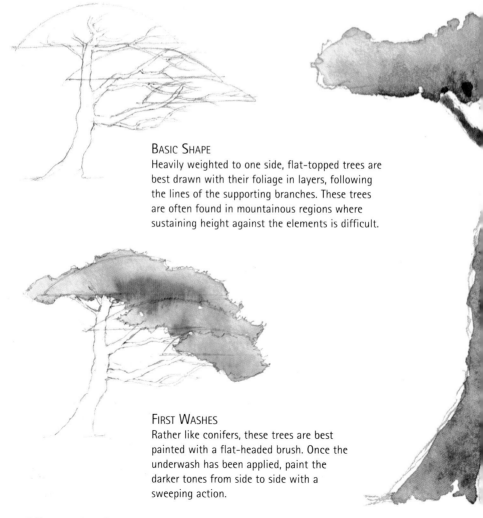

BASIC SHAPE
Heavily weighted to one side, flat-topped trees are best drawn with their foliage in layers, following the lines of the supporting branches. These trees are often found in mountainous regions where sustaining height against the elements is difficult.

FIRST WASHES
Rather like conifers, these trees are best painted with a flat-headed brush. Once the underwash has been applied, paint the darker tones from side to side with a sweeping action.

imbalance. In this situation, a useful technique is to apply plain water to dampen the paper on the side where the bulk of the foliage is to be found.

Subsequent applications of paint will then flow towards this section, accumulate there, and finally dry to a darker (but less solid) tone. This is one of the effects of placing wet paint onto already damp paper: the paint dries to a dark but graduated tone, rather than a solid, even shadow.

A flat-head or chisel brush can be used to shape both the tops and the bottoms of these trees in very much the same way as for creating the shapes of conical trees (see page 20).

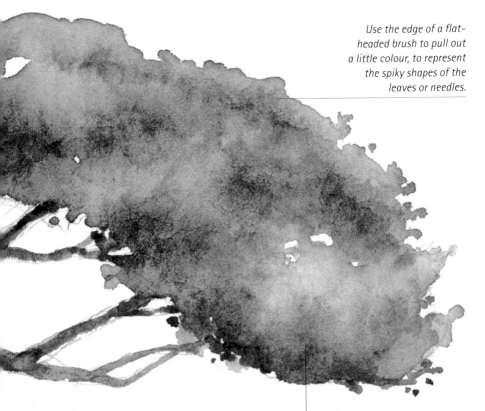

Use the edge of a flat-headed brush to pull out a little colour, to represent the spiky shapes of the leaves or needles.

DEVELOPED STUDY

Flat-topped trees differ from others in that they require some directional painting from the outset. The first wash established the shape of the top edge of the tree, and subsequent applications of paint are then 'pulled' across the shape of the tree.

Try to make sure that the branches you paint serve some purpose. Here, the bottom branches appear to be supporting the weight of foliage on the laden right-hand side of the tree.

One of the chief characteristics of *Acer* leaves is their sharp, distinctive points. Most trees hold so many leaves that it is not really possible to record individual leaves within the bulk of the tree. The smaller *Acer* trees, however, have particularly large leaves, and the scale of the tree can be suggested by including several of them in the preliminary drawing. You can then highlight these leaves by covering them with a basic wash of raw sienna and sap green, and then painting around them to visually push the individual leaves forward (see page 32).

If the areas behind these leaf shapes are painted using a flat-head brush, the sharpness of the brushstrokes reinforces the actual leaf shape. A flat-head brush also helps to determine the shape of the tree even further by allowing you to manipulate the paint and to create a sharply defined edge.

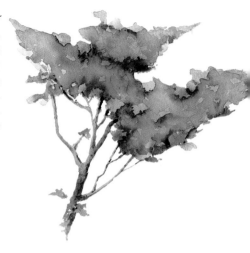

Including Detail
The size of the leaves on this tree allowed several to be picked out among the mass of foliage. Their sharp points are clearly perceptible and provide a visual counterpoint to the rest of the mass, and a link to the individual leaves below.

Using a Flat-head or Chisel Brush
Painting flat-topped trees requires a flat-head or chisel brush. These brushes feel different to the more commonly used round-headed brushes as they move less freely given their angular shape. However, you will discover just how quickly you can obtain sharp-edged directional brush marks.

1 First wash the undercoat colour in a sweeping side-to-side movement.

2 Mix the shadow colour and paint onto damp paper using the same sideways motion.

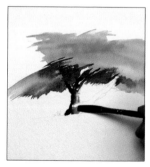

3 Create shadows on the trunk by 'pulling' the paint around the shape of the trunk.

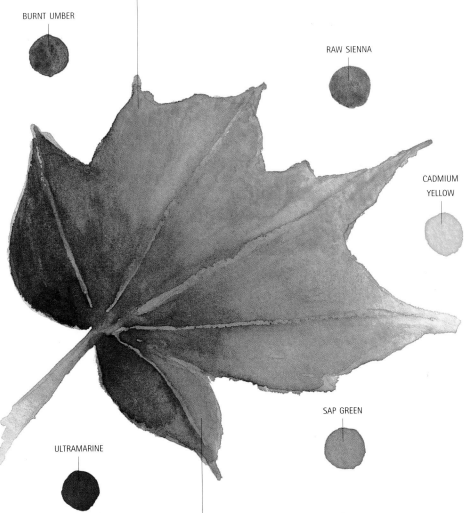

The range of colours used to paint this leaf is a mixture of natural earth colours and manufactured colours.

BURNT UMBER

RAW SIENNA

CADMIUM YELLOW

ULTRAMARINE

SAP GREEN

MAPLE LEAF

The key features of most leaves of the *Acer* family – Japanese maple, for example – are their highly decorative sharp points. This distinctive shape allows the direction of the veins to be clearly seen.

The best way to blend colours is to add paint to paper that has been washed with water – let the water on the paper do the work for you.

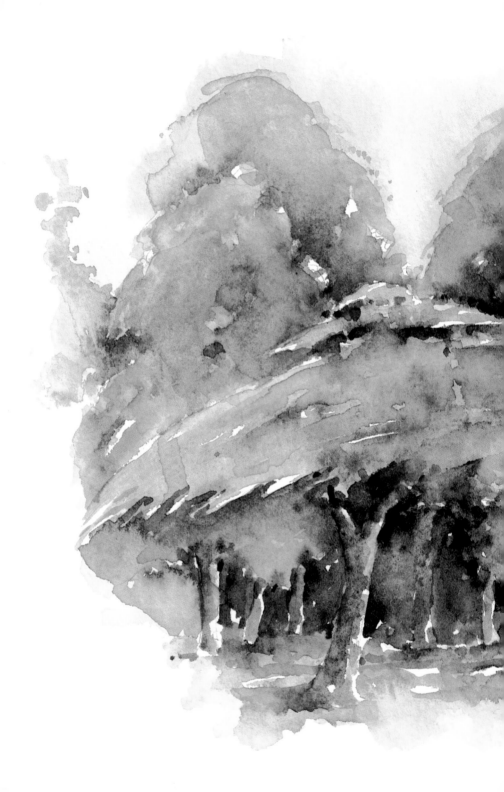

GROUPS OF TREES

Forests and woodlands, by their very nature, contain a wealth of different types and shapes of trees, usually growing in naturally random positions – and here lies the first challenge for the artist. How do you decide exactly which particular section of the forest or group of trees to paint? The main areas to consider are how attractive and visually appealing the group of trees you are looking at is, and just where the light is coming from.

Shapes and Tones

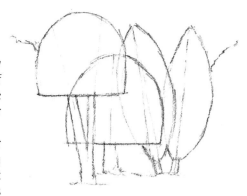

Although it is important to know how to construct the shapes of a variety of individual trees, it is very unusual to see single trees in total isolation in a forest or woodland setting.

However, the sight of a whole mass or tangle of trees, separated only by differing colour and tone, can be intimidating, so it is best to build up to whole forest scenes by focusing upon a small clump or group of trees – preferably a group of three or four trees that will require different construction shapes, and with differing tones or colours.

To help you focus in on a group of trees, it can be useful to carry a 35mm transparency mount to use as a viewfinder. Simply hold it at arm's length and move it about in your line of vision until you see the composition that you wish to paint contained within the rectangular frame of the viewfinder.

In the same way that photographers take a Polaroid snap to help them compose

Blocking In
With the basic shapes of this group of trees established, the next stage is to make some basic indications of the tonal values for each element. At this stage, there is no attempt at grading the tones.

a photograph, artists often make a small monochrome sketch before working on a composition. The illustrations on these pages show the various stages of constructing one particular group of trees. Once you have established the basic outline shapes, you can fill in and add detail to these shapes.

Wet into Wet
This is one of the most creative and expressive watercolour techniques. It involves applying wet paint from the palette to wet paint (or water) on the paper – when the two meet, the paints run and bleed into one another, finding their own way across the paper. The resulting paint then dries to a variety of tones.

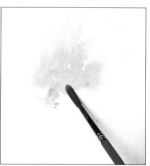

1 *Apply a watery paint to wet paper. The paint flows away from the brush and settles.*

2 *Add another watery colour. As this flows away and blends, it creates new tones and colours.*

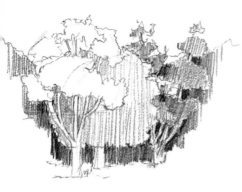

USING TONE
A monochrome tonal study can help you to see more of the shape and position of individual trees or groups by observing the positions of the lightest and darkest sections.

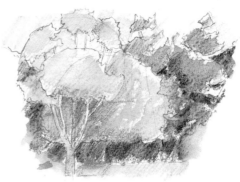

ADDING COLOUR
You can use water-soluble coloured pencils to make a colour sketch before moving on to a full-scale watercolour painting. Again, the lightest and darkest tones are blocked in.

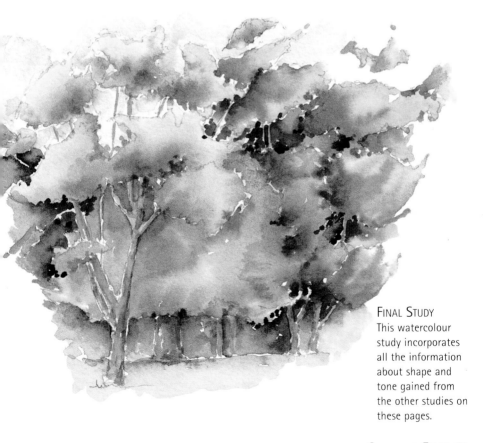

FINAL STUDY
This watercolour study incorporates all the information about shape and tone gained from the other studies on these pages.

Negative Shapes

Negative shapes are often to be seen in forests. These occur when the main subject of your painting is light in tone and stands out against a dark background – as in this example of a pale brown sycamore trunk. Normally in watercolour painting you work from light to dark – but it is tricky to paint a dark background around a light subject in a scene that contains many complex and irregular shapes.

To overcome this, incorporate the negative shapes right from the start. Sketch the selected shape lightly in pencil and then work around it when wetting the paper, leaving the shape dry. As wet paint does not readily run into dry paper, the dry areas will remain free of paint when the first wash of dark background colour is applied.

The next stage involves working on top of the underwash once it is dry. Paint a watery wash over the lighter-toned main subject, using broken brushstrokes so that some areas are left completely free of paint.

This technique can be developed to build up different layers of paint with several respective sets of negative shapes showing through from the previous underwash. It is also a useful way of suggesting generalized leaf shapes without endeavouring to paint every single leaf.

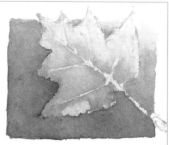

Light against Dark
Sometimes it is not enough to just leave a negative shape as white paper, or with only an underwash showing. This leaf is an example of a shape that required painting but still maintained a lighter tone than the background.

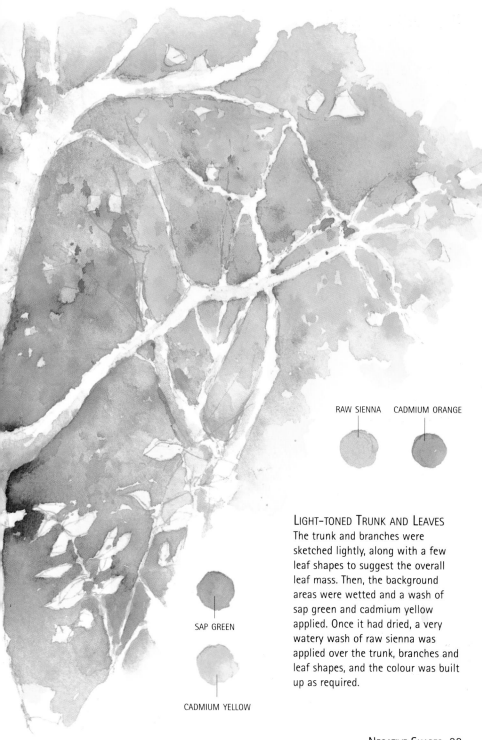

RAW SIENNA CADMIUM ORANGE

LIGHT-TONED TRUNK AND LEAVES

The trunk and branches were sketched lightly, along with a few leaf shapes to suggest the overall leaf mass. Then, the background areas were wetted and a wash of sap green and cadmium yellow applied. Once it had dried, a very watery wash of raw sienna was applied over the trunk, branches and leaf shapes, and the colour was built up as required.

SAP GREEN

CADMIUM YELLOW

Positive Shapes

Positive shapes occur when an object is darker than the background against which it is placed. This sketch, looking deep into the forest leaves and undergrowth, owes its strength to the positive shapes of the leaves that can be seen in both the foreground and the background.

The underwash – a wet-into-wet wash of raw sienna, cadmium orange and cadmium red – was applied and then left to dry. The leaves in the background were created by flicking small quantities of paint – burnt sienna and cadmium red – carefully onto the dried underwash. This is a technique that requires a little practice to ensure that you can control the direction of the paint and the quantity applied, but it does produce a spontaneous and random effect which will always help to create distant detail where no specific shape is required – only suggestion.

The leaves in the foreground were given a more considered treatment. These were painted using the same colours as the background leaves, only this time specific brushstrokes were used to create several individual shapes. While botanical accuracy is not required for this type of sketch, it does help to illustrate that different types of leaves are found in different areas of the forest.

If you do not visually attach positive leaves to a particular branch or stalk they can appear to float, enhancing the feeling of movement within your picture.

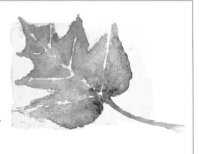

Dark Against Light
The leaf stands out clearly against the background. The background wash is a very dilute version of the colours that were used in the leaf – they were, after all, in the same scene.

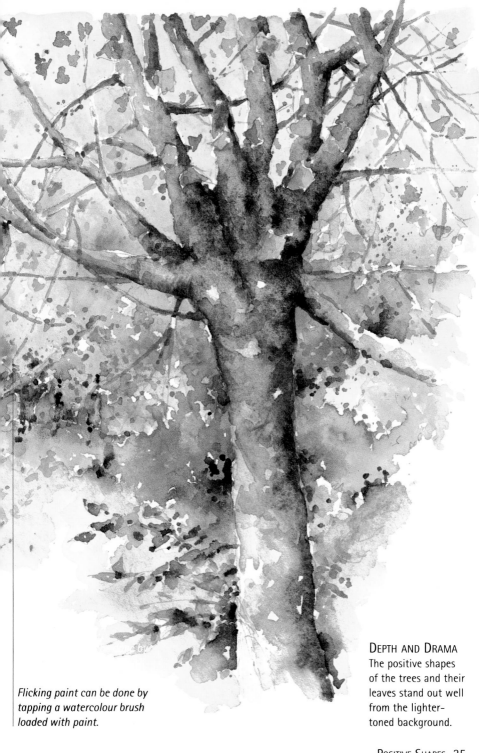

Flicking paint can be done by tapping a watercolour brush loaded with paint.

DEPTH AND DRAMA
The positive shapes of the trees and their leaves stand out well from the lighter-toned background.

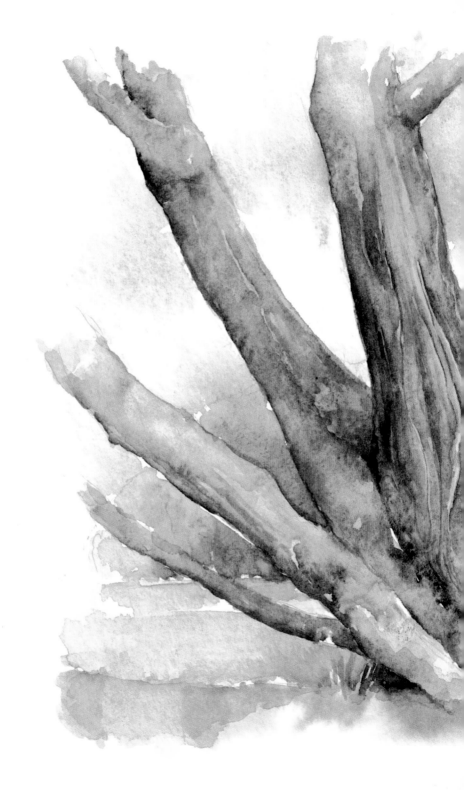

WOODLAND COLOURS

The variations in colour and tone in woodlands and forests are endless. Each season presents a new challenge, as not only the light and the weather, but also the very fabric of the forest adapt to the natural changes. The search for the right colours is never-ending, so it is a good idea to take time to establish the set of colours that best suits your requirements and personal style.

Greens

Many people might think that the colours to choose for painting woodland scenes are obvious: greens and browns. How wrong they would be! First, the choice of colours is certainly not simple: the cool blues of spring, the violet shadows of summer, and the oranges and reds of autumn each tell a very different story. Second, which greens and which browns? The colours found on art-store shelves are rarely identical with any colours to be seen in the natural world, and you will have to practise mixing your own colours. This way, you soon discover which particular commercially produced colours suit your needs.

The example on the opposite page shows the greens that I like to use, and how they are mixed. I tend to use sap green as a general, all-purpose green – this colour is a good mixer and can be used as a base for an extremely wide range of colours and tones. The key is to experiment and to make notes on the colours that you find useful, and exactly how you mixed them.

Art-store Greens
Most paints today are factory-produced to maintain longevity and consistency of performance. Despite these advantages, the colours in the tubes are not the greens we find in nature, and must therefore be used primarily as 'mixers'.

SAP GREEN HOOKER'S GREEN VIRIDIAN TERRE VERTE

Blue and Yellow don't always make Green
Try experimenting with as wide a range of commercially available paints as possible, to see exactly which colours combine to make the types of greens you wish to use. Label the results and keep them away from direct light so you can have a handy reference chart.

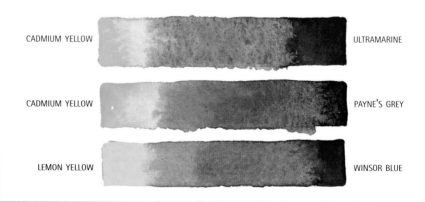

CADMIUM YELLOW — ULTRAMARINE

CADMIUM YELLOW — PAYNE'S GREY

LEMON YELLOW — WINSOR BLUE

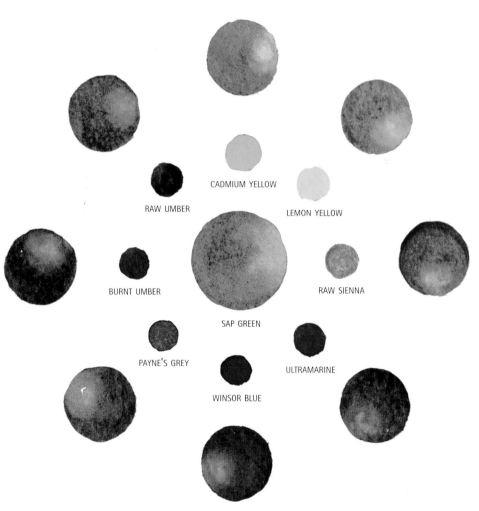

CADMIUM YELLOW

RAW UMBER

LEMON YELLOW

BURNT UMBER

RAW SIENNA

SAP GREEN

PAYNE'S GREY

ULTRAMARINE

WINSOR BLUE

Sap Green Mix

Although sap green is not a particularly useful colour for forests and woodlands on its own, you can use it as the principal ingredient in a whole range of mixtures. Even those shown here can be varied greatly by the proportions of each colour in the mix.

When mixing greens, it is not always a good idea to keep changing your water, strange as this may seem. Slightly tainted water can act as a binding medium, thus ensuring that all the colours and tones that you mix are visually related and connected.

You can mix tones by diluting paint in the palette – more water will always give you a lighter-toned paint. You can also vary tones by painting onto wet paper, which has the effect of diluting the tones even more. So don't just consider tones as varied mixtures of colour – think of the variety of tones that you can create through dilution.

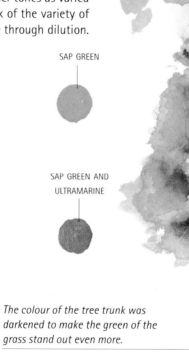

SAP GREEN

SAP GREEN AND
ULTRAMARINE

The colour of the tree trunk was darkened to make the green of the grass stand out even more.

A Mixing Challenge

Painted on a summer day, this woodland scene was awash with different shades of green, each of which forced me to mix a matching tone.

SAP GREEN AND
BURNT UMBER

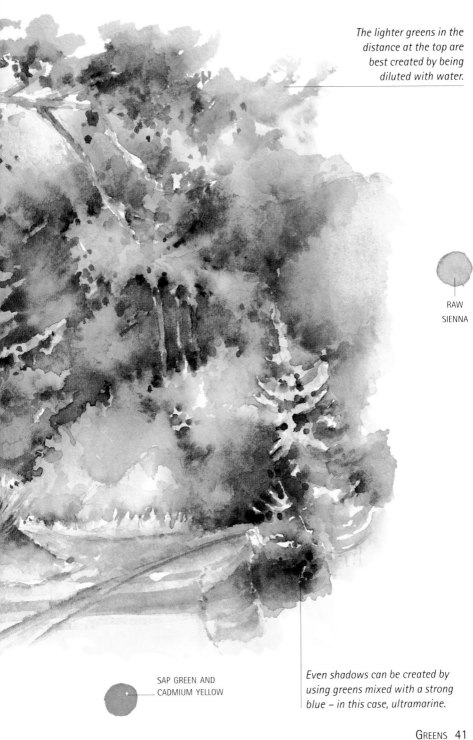

The lighter greens in the distance at the top are best created by being diluted with water.

RAW SIENNA

SAP GREEN AND CADMIUM YELLOW

Even shadows can be created by using greens mixed with a strong blue – in this case, ultramarine.

Examining Colours

Most of us grow up believing that skies are blue, trees are brown, and leaves are green. As we become visually more sophisticated and articulate, we soon learn that for an artist, life is not quite so simple and straightforward.

It is probably true to say that most tree trunks have a 'brown' base colour, but artists need to make many decisions upon which type of brown to use. As a general rule, I use a generic 'tree-trunk brown' mixture as a starting point, and develop this according to the type of tree and the respective colours and tones that are in front of me. This basic mixture consists of burnt umber and raw sienna with a touch of ultramarine.

Many trees found in forests or woodlands, however, need to have a series of additional colours added to increase the range of colours and tones that they contain – redwoods, for example, require a considerable amount of reddish burnt sienna in the mixture. In contrast, silver birches require a totally different base colour.

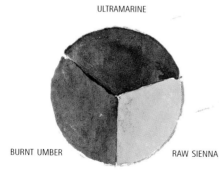

ULTRAMARINE

BURNT UMBER

RAW SIENNA

'Generic' Trunk
While the colours that are mixed are important, the method of applying them also matters – for instance, applying them wet-into-wet results in some colours 'separating' as they dry. This is great for some trees, but others require a smoother application of colour.

FINDING THE RIGHT MIX

Some tree trunks require a mix of up to six colours to record them. These colours are rarely mixed together on the palette, but are applied to damp paper and allowed to mix and blend on the paper, creating a more textured and natural look.

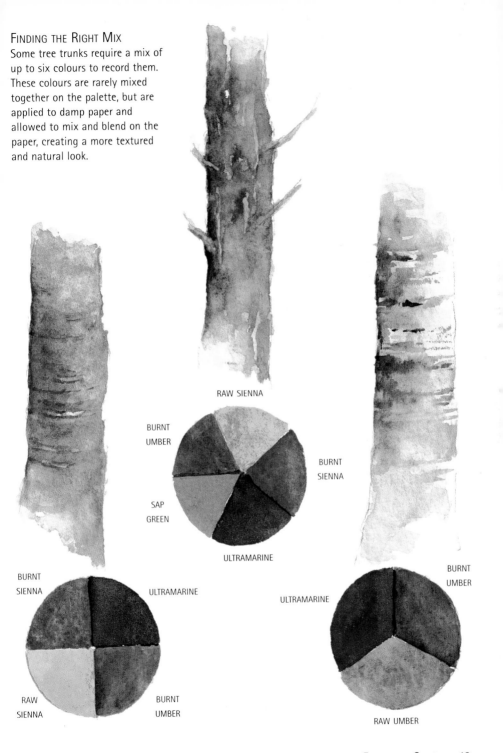

RAW SIENNA

BURNT UMBER

BURNT SIENNA

SAP GREEN

ULTRAMARINE

BURNT SIENNA

ULTRAMARINE

RAW SIENNA

BURNT UMBER

BURNT UMBER

ULTRAMARINE

RAW UMBER

Leaves are no different from tree trunks when it comes to colour mixing – a basic colour mix can be useful as a starting point, but it soon becomes limited when you examine the colours in a variety of leaves more closely.

My 'generic' leaf colour starts with sap green, to which I add a little cadmium yellow and a touch of burnt umber. The variations on this mix are not only from leaf to leaf, but from season to season: in the spring, I substitute lemon yellow for cadmium yellow, and in the autumn I use cadmium orange instead of cadmium yellow.

When painting leaves it is also important to turn them over and examine the undersides, as the colours here can be quite different in intensity.

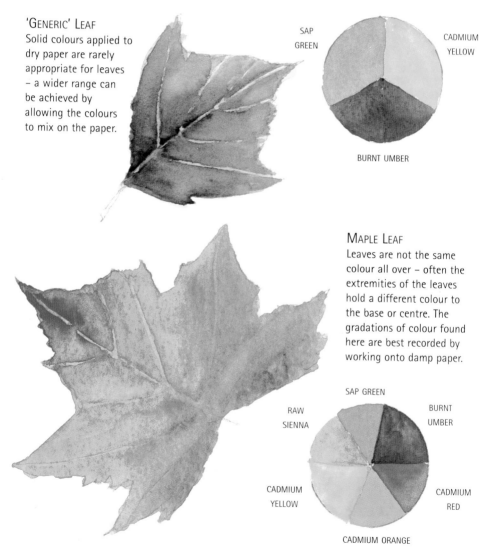

'GENERIC' LEAF
Solid colours applied to dry paper are rarely appropriate for leaves – a wider range can be achieved by allowing the colours to mix on the paper.

SAP GREEN

CADMIUM YELLOW

BURNT UMBER

MAPLE LEAF
Leaves are not the same colour all over – often the extremities of the leaves hold a different colour to the base or centre. The gradations of colour found here are best recorded by working onto damp paper.

SAP GREEN

RAW SIENNA

BURNT UMBER

CADMIUM YELLOW

CADMIUM RED

CADMIUM ORANGE

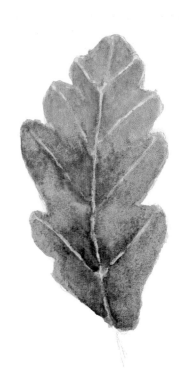

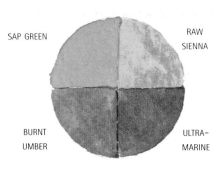

SAP GREEN

RAW SIENNA

BURNT UMBER

ULTRA-MARINE

OAK LEAF
An exciting and natural-looking range of colours can be created by allowing paints to mix together on damp paper, rather than mixing them on the palette and applying them to dry paper, which can make the colours somewhat 'flat'.

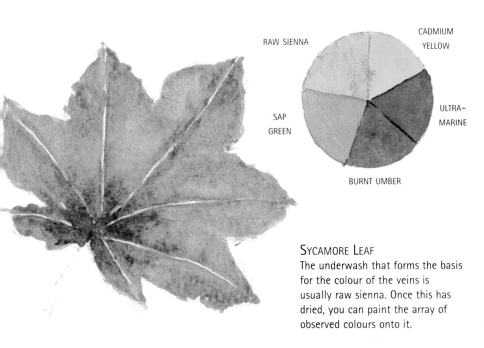

RAW SIENNA

CADMIUM YELLOW

SAP GREEN

ULTRA-MARINE

BURNT UMBER

SYCAMORE LEAF
The underwash that forms the basis for the colour of the veins is usually raw sienna. Once this has dried, you can paint the array of observed colours onto it.

Spring Colours

Spring colours tend to come from the cooler end of the colour spectrum – predominantly blues and lemon yellows.

The season's freshness can be recreated by informed choices about colour mixes. The cooler blues are cobalt blue and Winsor blue; Hooker's green has a strong blue element. Cadmium yellow can be used in spring forest scenes, but mixing in a little lemon yellow freshens the colour. The cool violets of bluebells, for example, can be mixed with Winsor or cobalt blue and a touch of permanent mauve. Although Winsor blue can be good in skies and greens, it can be rather overpowering on the ground.

Don't be concerned about mixing warm and cold colours together in a composition (such as warm greens and cool yellows) – often they work particularly well.

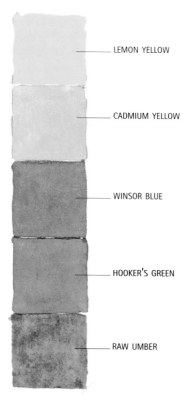

LEMON YELLOW

CADMIUM YELLOW

WINSOR BLUE

HOOKER'S GREEN

RAW UMBER

Using water as the medium, a wider variety of tones can be mixed on the paper.

Spring Palette

Few of the range of spring colours are used 'neat'. They need extensive mixing as not many of them are 'natural' colours. You can mix these paints in the palette or on the paper itself, using the surface water to carry the paint and mix it for you.

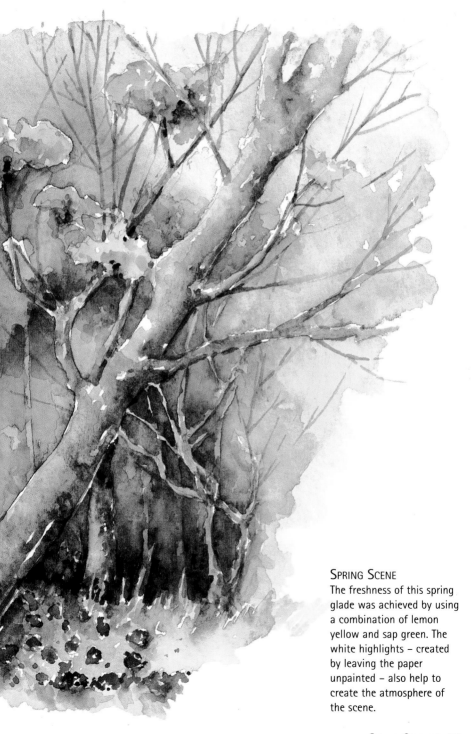

SPRING SCENE
The freshness of this spring glade was achieved by using a combination of lemon yellow and sap green. The white highlights – created by leaving the paper unpainted – also help to create the atmosphere of the scene.

Summer Colours

The sun-filled days of summer are best recorded using a selection of yellows and greens, reserving a little warm violet for the shadows. Sap green is a good starting point, adding the warmer cadmium yellow to develop the highlights. The more sunlight, the stronger the shadows, and these can be painted using a mixture of ultramarine with a touch of alizarin crimson or burnt umber. Both these colours have warm qualities and are ideal for turning a neutral colour or tone into summer shadows. The sharp, cold light of spring has been replaced by softer summer light, usually resulting in softer-edged shadows. To achieve this, allow the shadows to bleed into damp paper, or blot the edges.

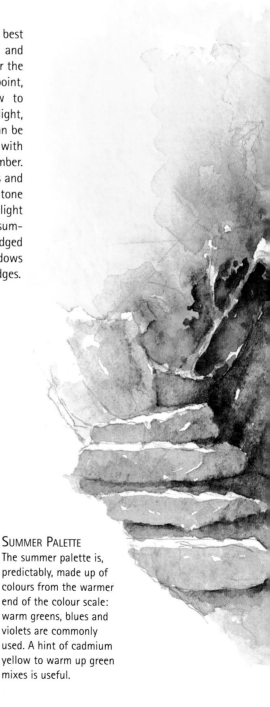

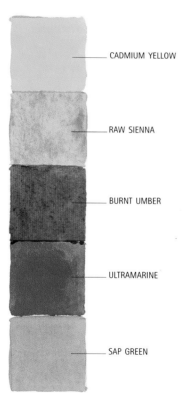

CADMIUM YELLOW

RAW SIENNA

BURNT UMBER

ULTRAMARINE

SAP GREEN

Summer Palette
The summer palette is, predictably, made up of colours from the warmer end of the colour scale: warm greens, blues and violets are commonly used. A hint of cadmium yellow to warm up green mixes is useful.

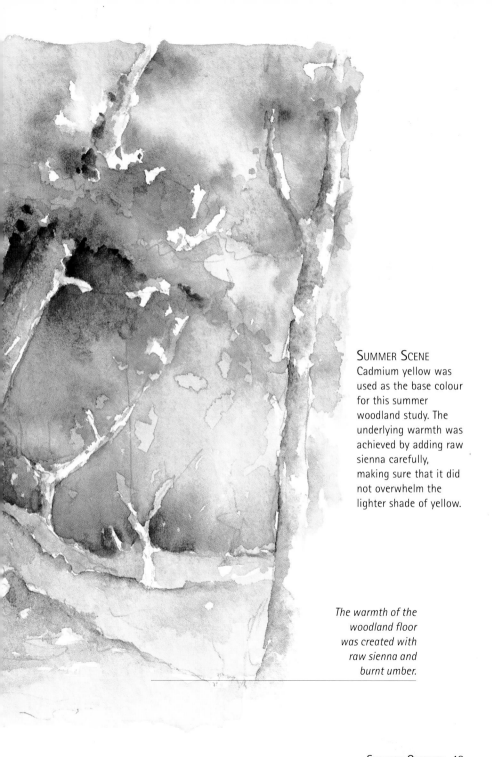

Summer Scene
Cadmium yellow was used as the base colour for this summer woodland study. The underlying warmth was achieved by adding raw sienna carefully, making sure that it did not overwhelm the lighter shade of yellow.

The warmth of the woodland floor was created with raw sienna and burnt umber.

Autumn Colours

This is the season of oranges, reds, golds and browns, largely created from the natural earth colours, with the occasional addition of the cadmium family.

Raw sienna is a good catalyst for colour mixes: this warm yellow colour mixes well with siennas and umbers as well as cadmium yellow and cadmium red to aid the 'golden' feel. Burnt sienna, a reddish-brown colour, is a good base for the addition of a few splashes of colour. In small quantities, pure cadmium red can look visually stunning when mixed with raw sienna, and even more so when a few neat flecks are introduced to a scene. Burnt umber and ultramarine work well for shadows.

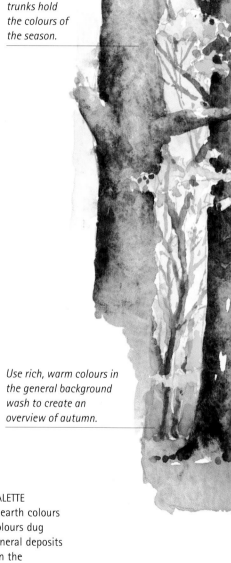

Even the tree trunks hold the colours of the season.

Use rich, warm colours in the general background wash to create an overview of autumn.

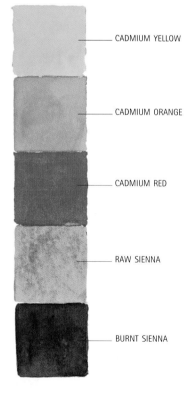

CADMIUM YELLOW

CADMIUM ORANGE

CADMIUM RED

RAW SIENNA

BURNT SIENNA

Autumn Palette
The natural earth colours are those colours dug from the mineral deposits that occur in the mountain regions of southern Europe. Given their organic nature, they are ideal colours for an autumnal palette.

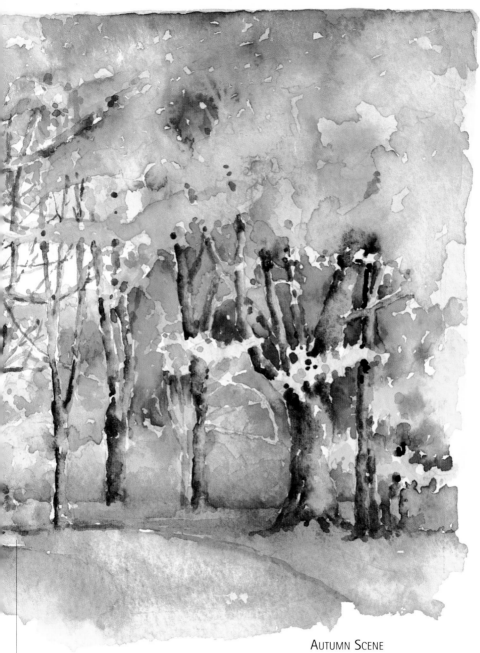

Dying leaves fall onto the forest floor; use colour mixes here as well.

Autumn Scene
The rich, autumnal colours were created by cadmium red and orange with a touch of burnt sienna, all allowed to blend freely.

Winter Colours

Winter in the woods is usually a time of cold, muted colours, often tinged with grey. Use terre verte (a grey-green), and Hooker's green (a blue-green) as the base for any greenery that still remains. Raw umber is a useful colour to add to your winter palette: this cool grey-olive colour is good for toning trees, branches and general ground cover.

For snow, leave the paper white and paint around it – I don't believe that you can ever find a purer or cleaner white than your paper. Snow, however, does hold some degree of tone, depending of course on the strength of the daylight. A cool blue/violet mixed with alizarin crimson and Winsor blue is my choice for capturing the effect.

The far trees are painted with a mixture of Hooker's green and terre verte with a touch of Payne's grey.

The white of the snow that has settled on the trees is best left as plain, unpainted paper.

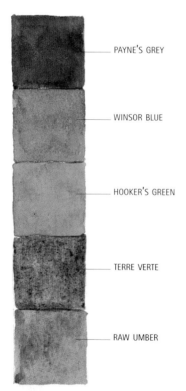

PAYNE'S GREY

WINSOR BLUE

HOOKER'S GREEN

TERRE VERTE

RAW UMBER

Winter Colours

The colours in a winter palette are those that can impart colour without any real richness. I use paints like terre verte and Payne's grey, which are both very 'thin' colours from the neutral end of the colour range.

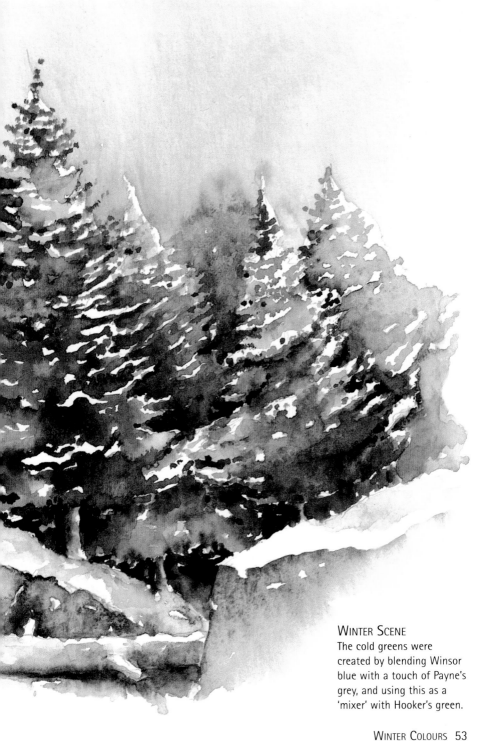

WINTER SCENE
The cold greens were
created by blending Winsor
blue with a touch of Payne's
grey, and using this as a
'mixer' with Hooker's green.

WOODLAND CLOSE-UPS

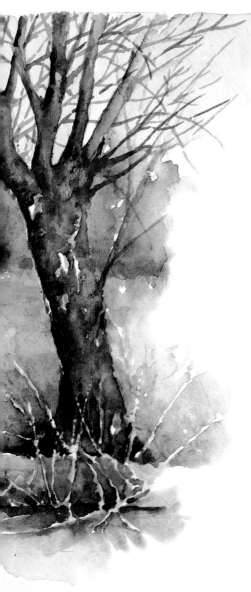

Much of the time spent amongst forests and woodland involves admiring and setting down on paper the colours of the trees, or the patterns created by shafts of light from above, and shadows on trees. But sometimes it is to the artist's advantage to look for other sources of inspiration; many of these can be found on the woodland floor, where a wealth of colour and textured objects are to be found.

Woodland Floor

Fungi, seed heads and shells, as well as berries and twigs, can appear in the most unusual and appealing shapes, colours and textures and make exciting subjects for the sketchbook studies.

It is quite easy to create these textures in watercolour, either by washing and blotting or, in the case of some fungi, splattering (see opposite).

More often than not, the colours on the forest floor come from a limited range, generally the natural earth colours (raw and burnt sienna, and raw and burnt umber).

Shape is another important factor when making close-up studies of found objects – curves, for example, can be best created by carefully blotting out the paint from the point at the top of the curve and allowing the paint to dry to a darker tone at the base of the object.

Washing and blotting is a watercolour technique that involves fairly quick action: wash watercolour paint onto a shape and then quickly blot chosen areas of the surface water with a piece of kitchen roll, thus creating a highlight.

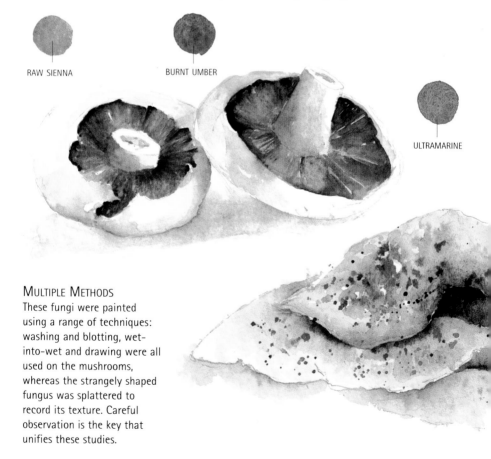

RAW SIENNA

BURNT UMBER

ULTRAMARINE

Multiple Methods
These fungi were painted using a range of techniques: washing and blotting, wet-into-wet and drawing were all used on the mushrooms, whereas the strangely shaped fungus was splattered to record its texture. Careful observation is the key that unifies these studies.

Splattering

Splattering helps to achieve the effect of texture on a small, pitted or naturally speckled object – from a stone or shell to a fungus or bird's egg. To achieve the effect, you need to splatter very watery paint onto dry paint only – on damp paper the 'splats' will bleed into it, negating the effect.

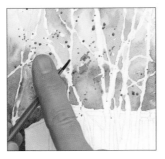

1 Dip a brush into very watery paint. Hold this over dry paint and tap the ferrule vigorously with your finger.

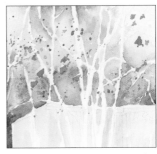

2 Change to another watery colour and repeat, building up a speckled layer of tones.

Using Tone

The limited colour range used in these studies means you have to experiment with tone. This is best done by working onto wet paper and ensuring that you use a lot of water in your mixtures. Apply several colours to a shape in rapid succession – as the colours dry they create a wealth of subtle tones.

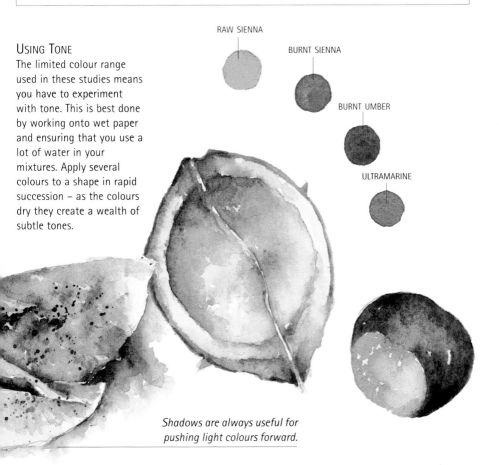

RAW SIENNA

BURNT SIENNA

BURNT UMBER

ULTRAMARINE

Shadows are always useful for pushing light colours forward.

Bark Textures

Close-up studies of the different types of tree bark found in any area of woodland or forest can be very rewarding.

Three main skills are used: colour mixing – subtle blends of tones go to make up the colours found on many tree barks; washing and blotting – blotting (see page 56) is particularly useful here; and drawing – when the underlying texture has been created and the paint and paper have dried, 'draw' onto the shape to create the lines of the bark.

The varied spacing of a tree's rings creates an unusual and irregular pattern, offering the chance to practise accuracy and clarity of line. The cross-section of a log is usually best painted with a raw sienna underwash, with a touch of burnt umber dropped into the very centre and allowed to bleed outwards. When this has dried, use a small brush to 'draw' onto the dried underwash using combinations of raw sienna, burnt umber and ultramarine.

Variations in Bark

The silver birch in the centre was painted with a flat brush pulled around the curve of the bark; the others used round brushes pulled downwards along the trunk's length.

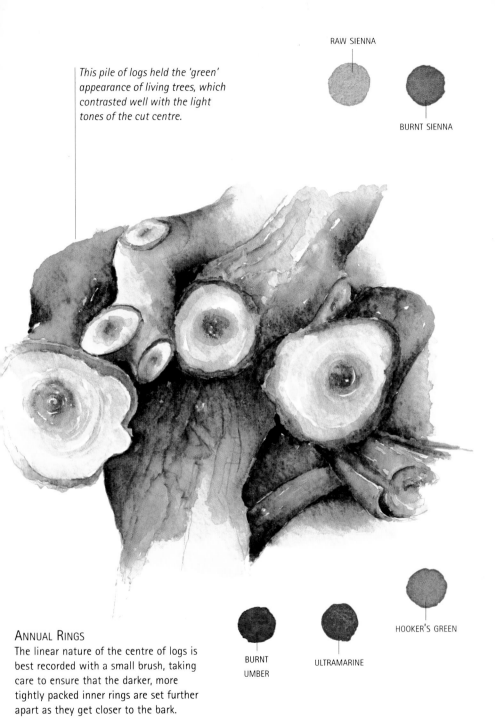

This pile of logs held the 'green' appearance of living trees, which contrasted well with the light tones of the cut centre.

RAW SIENNA

BURNT SIENNA

ANNUAL RINGS

The linear nature of the centre of logs is best recorded with a small brush, taking care to ensure that the darker, more tightly packed inner rings are set further apart as they get closer to the bark.

BURNT UMBER

ULTRAMARINE

HOOKER'S GREEN

FLOWERS AND LEAVES

The forest floor is always a good place to look for wild flowers and assorted growths. Remember that not all the leaves that you find in a forest fall from the trees – many grow from the floor upwards to meet the trees or, in the case of ivy, are seen on the trunk itself and are worthy of studies in their own right.

While wild flowers come into bloom chiefly in the spring, a wonderful range of ivies and ferns is present at all times. Give yourself the opportunities to study them and observe them exactly, so that you can feel confident in painting them when they make an appearance in a composition.

To ensure that your studies take on a more realistic look in your sketchbook, it is best to include some of their surroundings (if only a wash of pure colour) to give them a sense of existing within a particular space.

All the flower studies on these pages use the techniques of positive and negative painting (see pages 32 and 34). These methods ensure that most light colours have darker colours behind them in the shadow areas, visually thrusting them forward away from the page. To achieve this effect, I used a particularly deep green – sap green – and combined it with ultramarine and a touch of burnt umber.

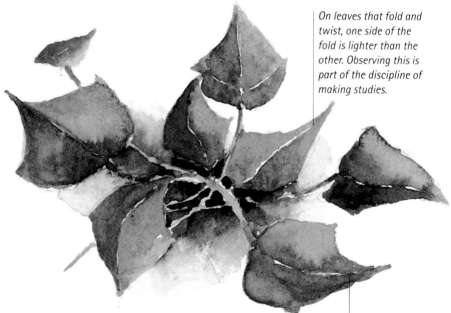

On leaves that fold and twist, one side of the fold is lighter than the other. Observing this is part of the discipline of making studies.

PAINTING IVY
Many varieties of ivy grow in woods, and it is worth while making as many studies as possible of the different types. You will find, as you do this, that different colours and tones are required, even within the same genus.

Deeper shades of green are created by the addition of the most appropriate blue.

CADMIUM ORANGE

LEMON YELLOW

*You may need to mix
two yellows to achieve
the correct colour.*

*Washing out
background colour
avoids clumsy
hard edges.*

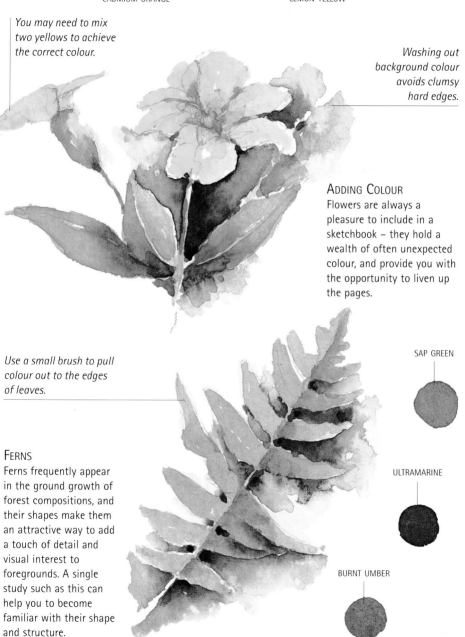

ADDING COLOUR

Flowers are always a
pleasure to include in a
sketchbook – they hold a
wealth of often unexpected
colour, and provide you with
the opportunity to liven up
the pages.

*Use a small brush to pull
colour out to the edges
of leaves.*

SAP GREEN

FERNS

Ferns frequently appear
in the ground growth of
forest compositions, and
their shapes make them
an attractive way to add
a touch of detail and
visual interest to
foregrounds. A single
study such as this can
help you to become
familiar with their shape
and structure.

ULTRAMARINE

BURNT UMBER

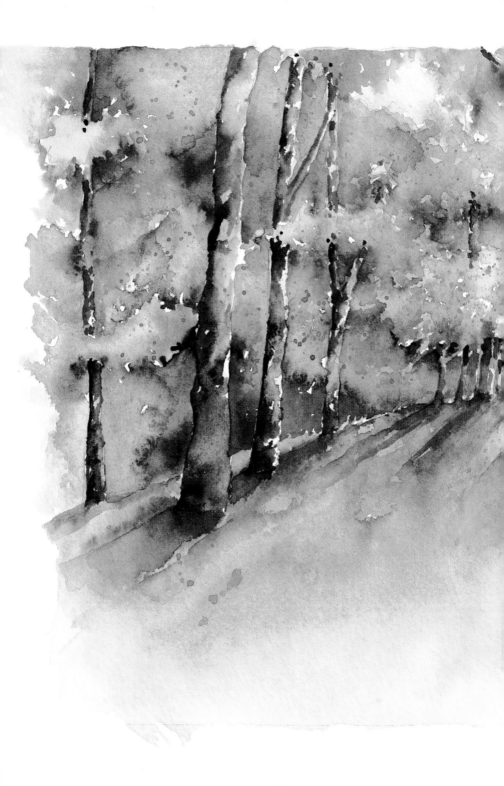

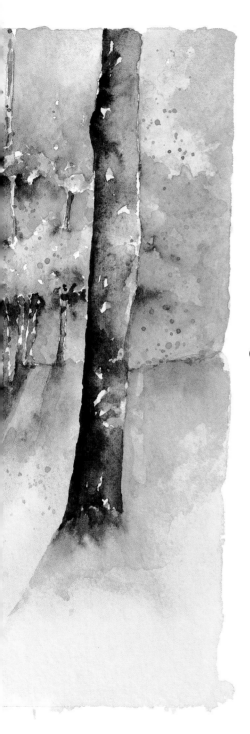

PRACTISE YOUR SKILLS

The previous sections of the book have been devoted largely to examining shapes, composition and colours and tones – all of which are invaluable practice if you intend to work 'on-site'. Now it's time to take a little longer over completing full-scale paintings – one for each season. The projects take you step by step through the processes that I use to create a 'finished' painting.

SPRING

Spring is a time of growth, when buds and flowers burst into the natural world. The forest floors are again free of snow and frost, and the green shoots can begin to push upwards.

Perhaps more than any other season, spring is a time when the forest floor can be just as interesting as the colours and shapes that can be found in the trees above the eyeline. One of the greatest delights of walking in a cool spring forest is to stumble upon a carpet of bluebells in a small shady glade, as the blues, violets and greens are all highly conducive to being recorded in watercolour. Soft bleeds, hard edges and strong flashes of colour are both the characteristics of the season and the fundamentals of watercolour painting.

I use blues from the cooler end of the spectrum – chiefly Winsor blue and cobalt blue – as my main mixers. Both impart a 'cold' quality to any other paints to which they are added. Winsor blue, in particular, is a very powerful paint that can easily dominate even the strongest colour mixes.

My other two main colours are Hooker's green, which I use for its cold tone, finding that only a little blue is needed to produce a sharp, cold colour; and lemon yellow, which I use mainly in highlights where spring sunlight is caught by fresh, new growth, thus requiring a bright flash of colour.

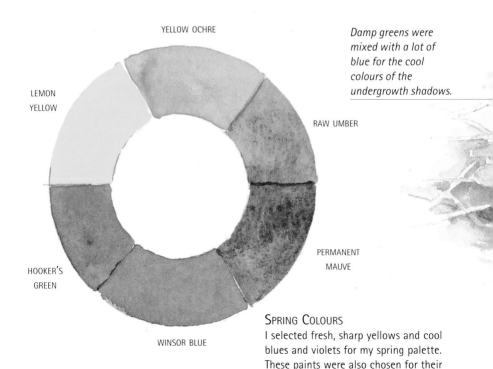

YELLOW OCHRE

LEMON YELLOW

RAW UMBER

Damp greens were mixed with a lot of blue for the cool colours of the undergrowth shadows.

HOOKER'S GREEN

PERMANENT MAUVE

WINSOR BLUE

SPRING COLOURS
I selected fresh, sharp yellows and cool blues and violets for my spring palette. These paints were also chosen for their mixing qualities.

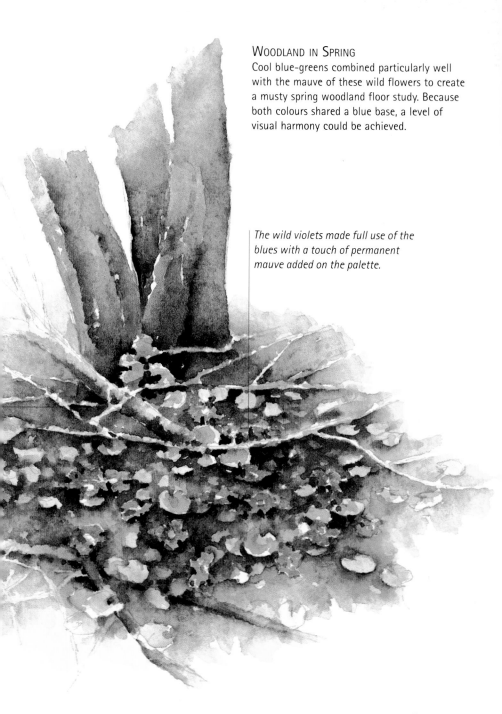

WOODLAND IN SPRING

Cool blue-greens combined particularly well with the mauve of these wild flowers to create a musty spring woodland floor study. Because both colours shared a blue base, a level of visual harmony could be achieved.

The wild violets made full use of the blues with a touch of permanent mauve added on the palette.

A CARPET OF BLUEBELLS

The intensity of colour in this spring blue-bell-carpeted woodland seemed to me to be an irresistible subject. The sharpness and clarity of the light on this cool, clear day made the violet ground cover almost jump off the ground.

The intensity of the light in this scene also meant that some degree of balance was required in the shadowed areas, and this resulted in my painting a very strong set of deep violet shadows into the fore-ground at the very last minute.

MATERIALS

- 500 gsm watercolour paper
- Brushes – 1 large (size 12), 1 medium (size 8) and 1 small (size 2)
- Watercolour pan paints – Winsor blue, Hooker's green, lemon yellow, cobalt blue, permanent mauve, raw umber, raw sienna
- Water container

1 *I dampened the sky area with water and applied watery Winsor blue with a medium-sized brush and allowed it to bleed. The area where the sky and trees met was painted with a watery mixture of Hooker's green and lemon yellow.*

2 *The areas where the foliage shows through the trees were painted in the same way, dampening the foliage sections. On the still-damp paper, I applied watery washes of cobalt blue, Hooker's green and lemon yellow, allowing them to bleed freely.*

3 To create the colours for the ground cover of bluebells, I dampened the paper between the tree shapes and applied a very strong mixture of permanent mauve, mixed with a touch of the sky colour to maintain a balance between the top and bottom.

4 The initial stages of the painting were made very quickly, with a succession of washes being applied and left to bleed. Now I could start to think about the tones and colours required to develop the background.

5 The colours of the new growth were created by applying washes of darker greens and yellows. Working onto dry paper with a small brush, the paint stayed where it was without too much bleeding, so it was easier to describe the shapes of the bushes and trees.

6 *I fixed the connection between the background and foreground by applying a combination of Hooker's green paint and a lot of burnt umber and cobalt blue to the 'line' where the two sections appeared to meet.*

7 *Next, I applied a mixture of raw umber and cobalt blue to the background trees with a small brush along their left-hand side, leaving a few white highlights on the opposite sides to indicate the direction of the light.*

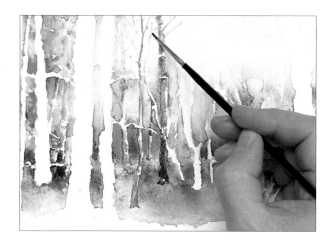

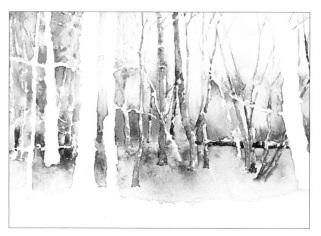

8 *As I continued across the background and middle ground, I made sure that the trees furthest away were the lightest and that the colour mixture was strengthened. I allowed some branches to remain as negative shapes, acting as highlights.*

9 *Using a flat-headed brush to paint the thicker trees in the immediate foreground enabled me to record both shape and texture, and allowed me to create a sharp line along the edge of a tree. I dragged the paint around the shape of the tree, copying the line of the bark. INSET: A few adjustments were made at this point to the trees – chiefly darkening the shaded side by applying a darker mixture of raw umber and cobalt blue, and allowing it to dry with a hard edge, emphasizing the shadow.*

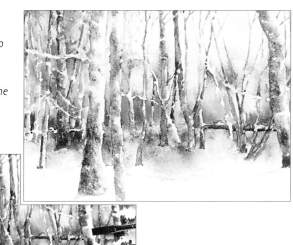

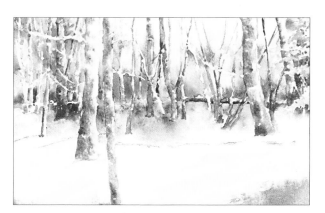

10 *On the immediate foreground I applied a wash of pure raw sienna. Next, I applied a cool mixture of Hooker's green and cobalt blue to the bottom edge of the still-damp paper. This bled gently upwards, creating a feathered, grass-like appearance .*

11 *For the shadows, I mixed together nearly all of the colours in the palette to create a blue/violet grey and then, using a medium-sized brush, pulled the paint along the line of the cast shadows, easing off the pressure towards the end of the shadow.*

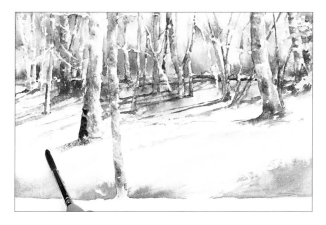

KEEPING BALANCE

The most important element
in this scene is the balance of
light and shade. However, it is
not a painting of simple
extremes – the range of tones
between the poles of light
and shade maintain the
balance. Don't ignore the
balance between warm and
cold colours, either.

*The fresh lemon yellows of the
background foliage are a
direct result of the strength of
the light.*

*The complex web of shadows
is almost drawn onto dry
ground-cover paint.*

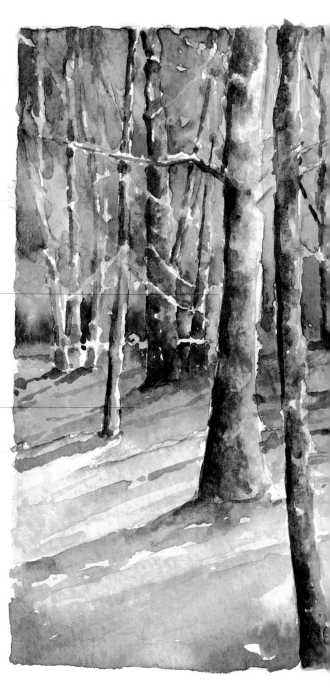

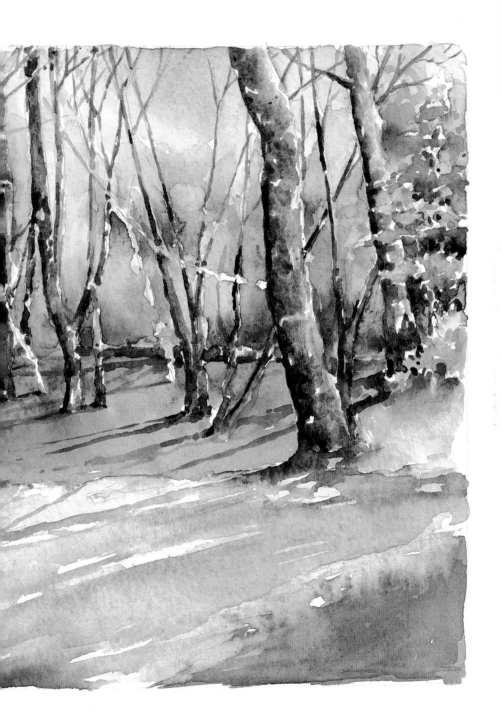

SUMMER

Summer is a peaceful and relaxing time in which to paint amid the gentle warmth of lush green forests and woodlands.

Because the weather is usually a little more predictable during the summer months, you may feel inclined to explore the greater depths of forests, where the shadows are darker and the foliage more overgrown and heavy with blue and violet shadow tones. Alternatively, you might like to climb high above the timber line, as in the following demonstration, and look down on a forest, recording the vast expanse of woodland receding into the far distance. This way, you can achieve an alternative view to traditional woodland painting.

Whichever viewpoint you choose, you will encounter many similar characteristics in summer woodlands – in particular, the colours. I tend to use much more yellow in summer, but not the cool, sharp yellow of the spring days. Cadmium yellow is a warm and powerful colour that can easily dominate any colours to which it is added – chiefly sap green – and this can be used to create a few gently rustling leaves.

At the other end of the scale are the deep shadows. I use ultramarine as my main blue, for its warmth of tone, and often add a touch of alizarin crimson to it, to create some deep damp- and heat-soaked shadows on the woodland floor.

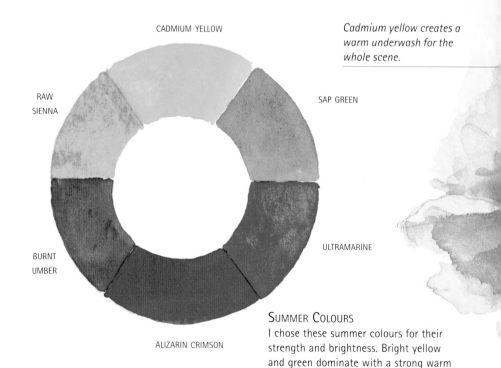

CADMIUM YELLOW

RAW SIENNA

SAP GREEN

BURNT UMBER

ULTRAMARINE

ALIZARIN CRIMSON

Cadmium yellow creates a warm underwash for the whole scene.

SUMMER COLOURS
I chose these summer colours for their strength and brightness. Bright yellow and green dominate with a strong warm blue for blending.

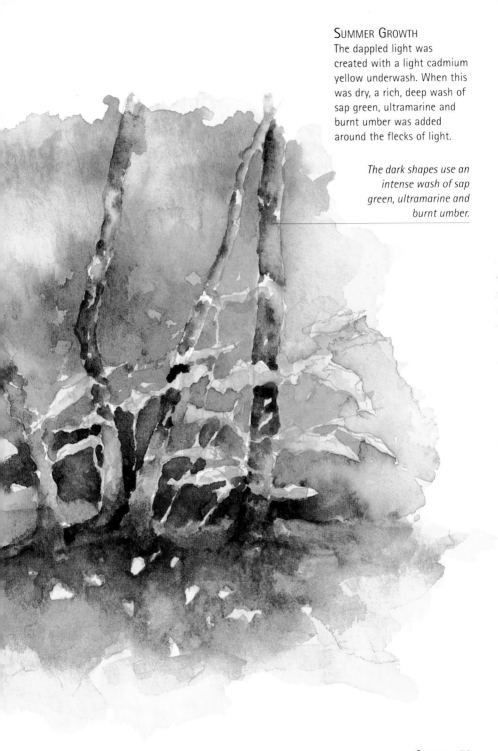

Summer Growth

The dappled light was created with a light cadmium yellow underwash. When this was dry, a rich, deep wash of sap green, ultramarine and burnt umber was added around the flecks of light.

The dark shapes use an intense wash of sap green, ultramarine and burnt umber.

Woodland Panorama

In forests and woodlands, most of your painting time involves painting the trees that you see at eye level, and looking upwards to the trees that tower above you. Sometimes, however, it is good practice to find a position above the timber line that allows you a view of tree tops from above.

This composition requires looking at trees in a different way, and developing the skills of layering as you complete the composition from the far distant background to the immediate foreground.

MATERIALS
- 500 gsm watercolour paper
- Brushes – 1 large (size 12), 1 medium (size 8) and 1 small (size 2)
- Watercolour pan paints – sap green, ultramarine, alizarin crimson, raw sienna, cadmium yellow, burnt umber
- Water container
- Kitchen roll

1 *To establish the warm summer sky I applied ultramarine with a large wash brush onto damp paper to create an even covering. The soft, white clouds on the horizon were created by blotting out the damp paint with kitchen roll.*

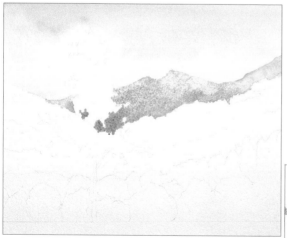

2 *For the mountain in the furthest distance I mixed a lot of ultramarine with a little alizarin crimson and a hint of sap green to suggest the tree-covered mountainside. INSET: I made a darker mixture of the same colours and ran this along the base line dividing the background and the middle ground.*

3 *While the tops of the hills appeared light against the dip behind, the base was much darker. I added a little cadmium yellow to the basic ultramarine and sap green mixture.*

4 *I continued layering across the middle group, creating highlights at the top of hills and shadows in the valleys, working with a medium brush to create the bulk of the colour and a small brush to darken the tones at the base.*

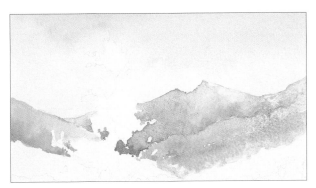

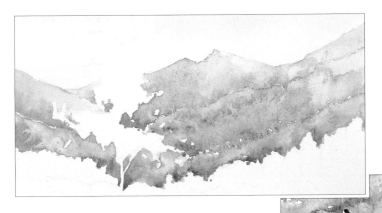

5 *To emphasize the shape of the tops of the trees, I introduced a little raw sienna, and continued the layering of the forms with some detailed painting into the valleys. INSET: As the paint dried, so the intensity of the colours faded a little – this was the time to consider the situation and to make a few decisions regarding areas that needed darkening.*

6 *I dampened the areas that needed darkening a little, and left them for a few seconds for the water to sink into the paper. Then, using a small brush, I applied a mixture of sap green, ultramarine and a touch of burnt umber.*

7 *Next, I continued this process to fill the bulk of the tree shapes that made up the middle ground. To complete this section I painted a little cadmium yellow onto the top of the trees to represent the summer highlights.*

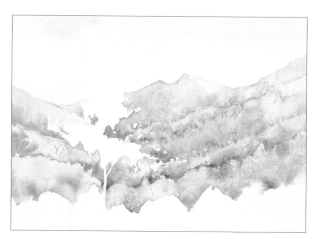

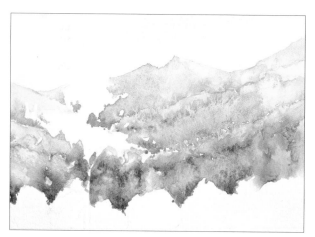

8 *Before moving on to the foreground, I established the darker tones that would 'push' the front layer of trees forward using a small brush and the mixture described in Step 6.*

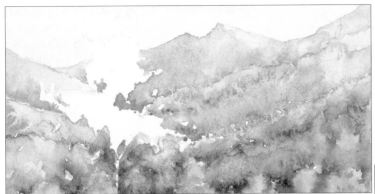

9 *Next, I dampened the paper for the foreground trees, and then painted it with the addition of a little raw sienna to the mixture, allowing the paint to bleed downwards. INSET: To make the tree shapes much more pronounced in the foreground, I then 'drew' the shadows behind the dried wash, giving each tree an individual identity.*

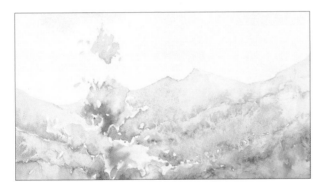

10 *The highlights on the tree in the immediate foreground had to be the lightest in the composition. I painted them by dropping onto damp paper a mixture of cadmium yellow and the slightest touch of sap green.*

11 *As the main area of focus, the foreground tree also had to have the darkest shadows (sap green, ultramarine and burnt umber). I applied these to dry paper to avoid dilutions, and allowed them to bleed into the immediate highlights to create a few 'middle' tones.*

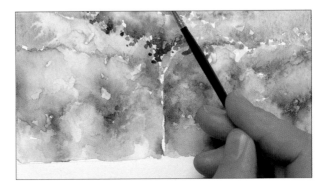

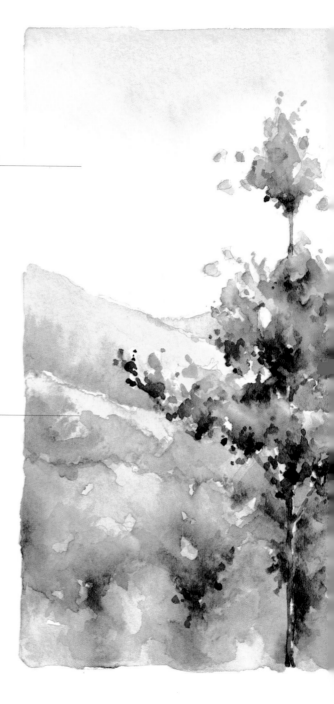

More sky is evident in this scene than is often found in woodland scenes – this was painted onto damp paper to create an even flow of paint, resulting in a smoother finish.

The layering of trees was created by using dark colours to 'push' the lighter ones forward.

TONE VS COLOUR

This summer scene relied on the creation of a wealth of tones, rather than the use of a range of colours – in fact, fewer colours may be required in a summer scene than you might expect. The violets in the background are the result of tonal mixing using only a limited palette.

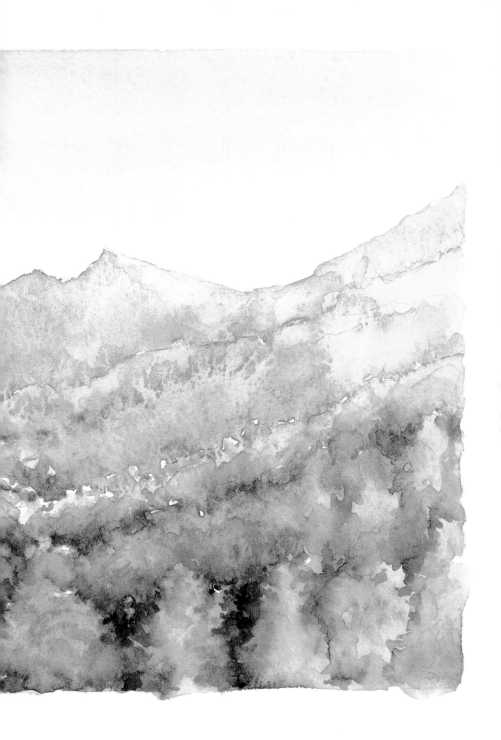

Autumn

Autumn is truly a 'golden' time to be out and about in forests and woodlands. The colours to be witnessed as the year begins to draw to a close can be remarkable. The fiery reds, mixed with scarlet lake or cadmium red and burnt sienna; the golden yellows, mixed with cadmium yellow and raw sienna; and the deep browns, mixed with burnt umber and ultramarine – these are all a pure pleasure to record.

But it isn't just the colours that are so appealing. As summer reaches its end the leaves start to fall from the trees, exposing a whole new vista. Stark, skeletal structures replace the wealth of green foliage, offering a much more linear approach to recording the scene. The technique of recording falling leaves by flicking and dotting paint is explored in this project. While not unique to the season, it is a particularly appropriate technique for recording golden forest days.

At this time of year I tend to use raw sienna as an underwash, as it maintains a warm tone when diluted. The translucent qualities of the other colours added in further layers result in the underwash dominating the scene from the start. Autumn is also a time for experimenting with colours – mixed on the palette, applied neat, or allowed to bleed into each other on damp paper, creating unexpected tones.

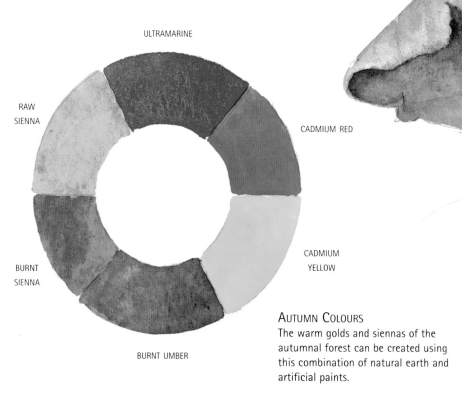

ULTRAMARINE

RAW SIENNA

CADMIUM RED

BURNT SIENNA

CADMIUM YELLOW

BURNT UMBER

Autumn Colours
The warm golds and siennas of the autumnal forest can be created using this combination of natural earth and artificial paints.

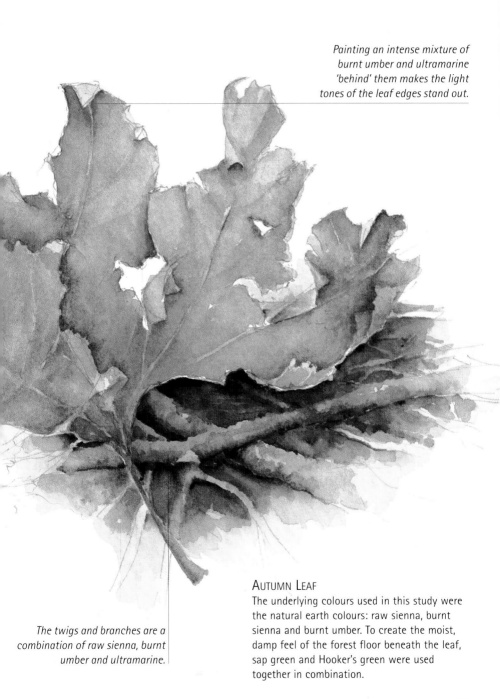

Painting an intense mixture of burnt umber and ultramarine 'behind' them makes the light tones of the leaf edges stand out.

The twigs and branches are a combination of raw sienna, burnt umber and ultramarine.

AUTUMN LEAF

The underlying colours used in this study were the natural earth colours: raw sienna, burnt sienna and burnt umber. To create the moist, damp feel of the forest floor beneath the leaf, sap green and Hooker's green were used together in combination.

FALLING LEAVES

The intensity of colours in this gentle autumn scene required more than one technique to record its atmosphere.

First, I used wet-into-wet to create a whole range of tones in the background. Next, many of the shapes of the trees and leaves were recorded as negative shapes (see page 32), where I needed to exercise full control over the application of the paint. Finally, I flicked paint onto dry paper to create the illusion of leaves rustling on a warm autumn breeze.

> ### MATERIALS
> - 500 gsm watercolour paper
> - Brushes – 1 large (size 12), 1 medium (size 8) and 1 small (size 2) round-headed, plus 1 medium flat-headed
> - Watercolour pan paints – raw sienna, burnt sienna, burnt umber, sap green, cadmium orange, cadmium yellow, ultramarine
> - Water container

1 *Raw sienna was an obvious choice for a warm, rich golden underwash. I applied a watery mixture to areas of paper that had been previously dampened, and allowed it to bleed freely and dry to irregular patches of tone.*

2 *Before the underwash dried completely, I applied raw sienna, burnt sienna, burnt umber and a touch of cadmium yellow to it and allowed the paint to bleed, working carefully around the negative shapes of the bare branches and leaves.*

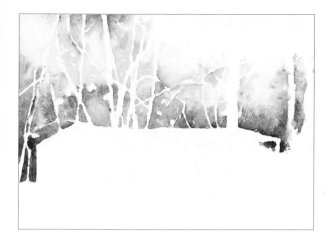

3 *I continued this process, working rapidly before the damp underwash dried. Eventually, all the tree and leaf shapes were pure white shapes, with a riot of red and golden colours thrusting them into the foreground.*

4 *Once the background was dry, I painted the bush and scrub in the middle ground with a mixture of cadmium orange and burnt sienna. The section at the top was left light to contrast with the dark background colours. The bottoms of the bushes had a little burnt umber added to the mixture, to 'attach' them to the ground.*

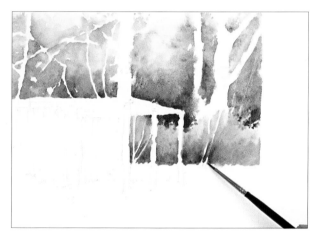

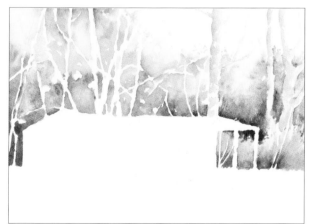

5 *It was now time to develop some detail in the trees. I first treated the large tree trunks to a thin wash of raw sienna, working with a small brush on dry paper. A few strips of white paper were left unpainted to act as highlights.*

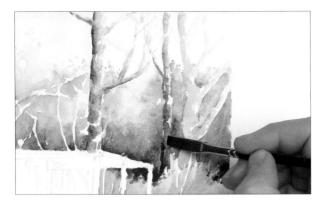

6 With the tree underwash dry, I used a flat-headed brush to run a strong mixture of burnt umber with a touch of ultramarine along the shaded side of the trees, using broken brushstrokes. I pulled this around the shapes of the tree to create curvature.

7 After loading a small brush with a strong and very wet mixture of burnt sienna and a touch of raw sienna, I held it over the painting and vigorously tapped the ferrule to splatter flecks of paint. I then painted a few specific leaf shapes.

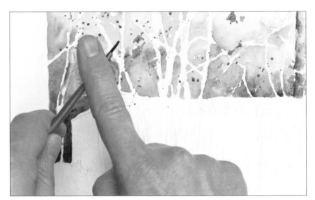

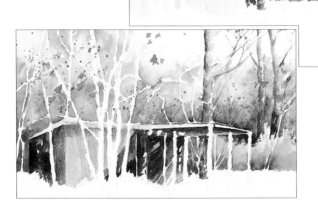

8 The next stage was to begin to paint the central part of the scene – the wooden hut. Initially, I treated this with a thin wash of raw sienna to establish the base colour, still working carefully around the negative shapes of the clump of trees in the foreground. INSET: Once the underwash had dried, I used a medium-sized brush to apply a mixture of burnt umber and ultramarine to the shaded side of the hut and underneath the canopy, pulling the paint in a diagonal direction to achieve a sense of direction for the shadows.

9 *When the blocks of shadow had dried, I painted a few planks using a small brush and a much-diluted version of the shadow mix. This same mixture was used to emphasize the broken nature of the light by almost drawing onto the canopy supports, leaving flashes of underwash showing to suggest highlights.*

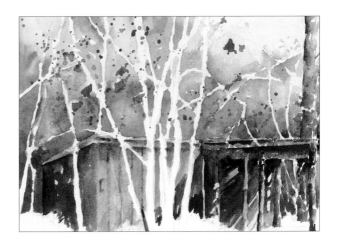

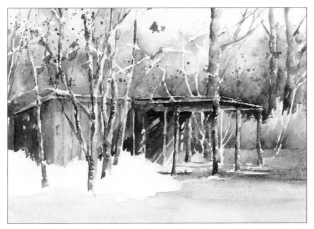

10 *The foreground colour was created by adding a little raw sienna to a mixture of all the colours in the palette. Using a dry, medium brush, I dragged this across dry paper to develop a few flecks of highlighting. Before this dried I quickly pulled a little burnt umber and ultramarine across the paper to the line of the foreground shadows.*

11 *To finish, I painted the trees in the immediate foreground using a flat-headed brush, with the highlights on the right-hand side. For the patches of scrub grass around the base of the trees, I applied sap green and raw sienna to damp paper with a medium-sized brush.*

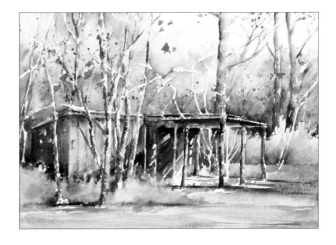

The random method of splattering paint across the upper sections is very effective for suggesting the movement of leaves.

The deep, warm tones are created by painting pure colours onto wet paint and allowing them to bleed.

MOVEMENT AND LIGHT

The interplay of the positive and negative shapes in the branches and leaves is the key to this scene. While the autumnal colours describe the scene well, it is the sense of movement in the 'floating' leaves and flashes of light on the branches that really make the picture come to life.

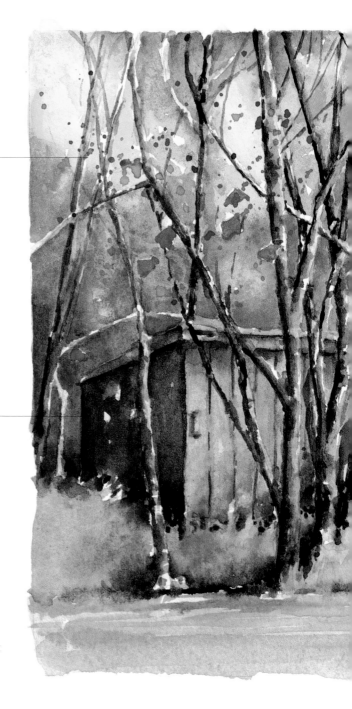

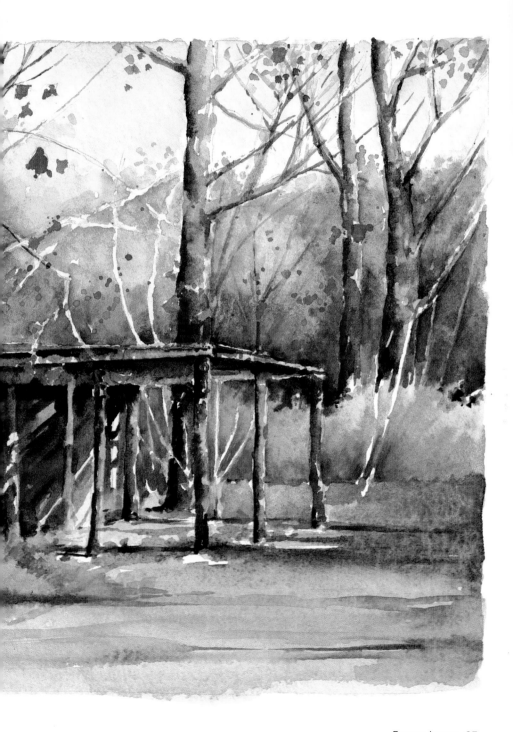

WINTER

Winter is one of the least predictable times for painting on-site in forests and woodlands – you can always expect cold, but just how cold and how quickly snow can fall are always unknown quantities. You can, however, experience some very still days in woodlands when the winter sun casts pale violet and orange-tinged shadows onto deep-piled snow, and the coldness seems to be absorbed by the beauty of the scene.

The colours I use to paint snow-laden trees and forests are taken from the more neutral range of paints – Payne's grey and terre verte, for example. Both have little value of their own, but they are very good for mixing to either tone down colours, or to underpin a cool feel in a scene.

Unlike the previous demonstrations, in this one the colours are mixed in the palette because a higher level of control needs to be maintained over their use. If overused or allowed to run unchecked into your scene, neutral colours can easily make a landscape appear flat.

Perhaps surprisingly to some people, I chose not to use masking fluid (to keep the white paper free of paint. While it can be a valuable medium – and I certainly do make use of it – I came to the conclusion that spontaneity was the most important factor in this particular scene.

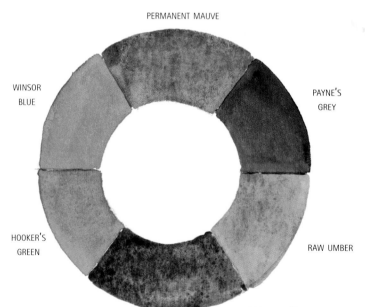

PERMANENT MAUVE

WINSOR BLUE

PAYNE'S GREY

HOOKER'S GREEN

RAW UMBER

TERRE VERTE

WINTER COLOURS
The colours I selected for my winter palette are cool, more 'neutral' paints that, however, they are mixed, usually produce slightly muted tones.

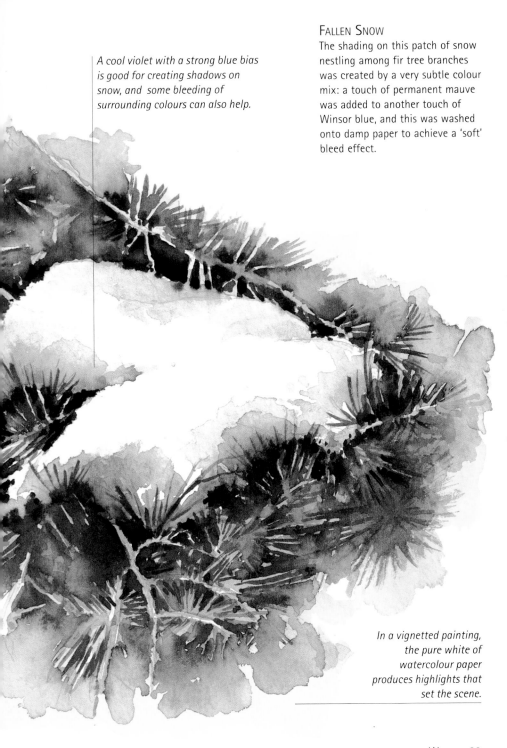

A cool violet with a strong blue bias is good for creating shadows on snow, and some bleeding of surrounding colours can also help.

FALLEN SNOW

The shading on this patch of snow nestling among fir tree branches was created by a very subtle colour mix: a touch of permanent mauve was added to another touch of Winsor blue, and this was washed onto damp paper to achieve a 'soft' bleed effect.

In a vignetted painting, the pure white of watercolour paper produces highlights that set the scene.

Snow-laden Forest

In a winter scene such as this project, although snow itself does not really have a colour, it does both hold and reflect all the colours that surround it. The colours of the shadows witnessed in forests is worth studying by any artist. Forests will always create shadows, due to the number of trees and branches – the shadows cast onto snow will often take on a cool violet tint and are best mixed with either Winsor or cobalt blue (both colours are known for their cool qualities) and a touch of alizarin crimson.

Materials

- 500 gsm watercolour paper
- Brushes – 1 large (size 12), 1 medium (size 8) and 1 small (size 2) round-headed, plus 1 medium flat-headed
- Watercolour pan paints – Winsor blue, terre verte, Hooker's green, cobalt blue, Payne's grey, raw umber, burnt umber alizarin crimson
- Water container

1 *To create a cold sky I painted Winsor blue evenly onto damp paper. Before this dried, I applied a mixture of terre verte, Hooker's green and Winsor blue onto the background trees and encouraged it to bleed a little into the sky, to suggest the soft qualities created by distance.*

2 *To create variety, I added Winsor blue and cobalt blue to the mixture, occasionally adding a little Payne's grey to ensure depth of tone. The feathering effect of applying paint onto damp paper helped to create the look of pine trees.*

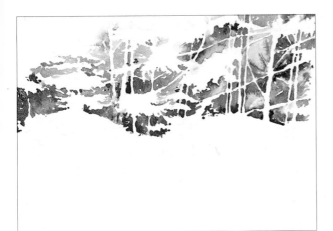

3 As I continued, I left most of the white areas unpainted, or barely tinted to act as snow – especially the areas at the top of the pine needles and along the tops of the branches where the sky and trees meet.

4 To achieve the effect of snow blown onto the trunks, I ran a mixture of raw umber and cobalt blue along the edge of the bare tree trunks with a small brush and allowed it to dry.

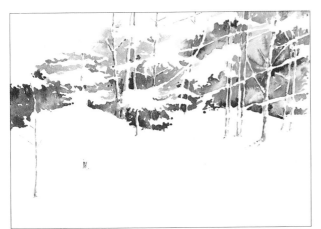

5 Now was the time to make any minor adjustments that were required to the background colours. I sharpened one or two of the tree shapes by drawing onto the darkest shapes with a small brush, with the effect of pushing the lighter trees forward.

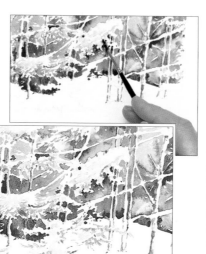

6 The tops of the branches and clusters of needles on the middle-ground trees were left pure white, and I painted the lower areas with a mixture of Hooker's green and cobalt blue and a touch of raw umber, using the point of a small brush to dot on the paint. INSET: To make the floating clumps of greenery and long branches stand out against the background, I used a strong paint mixture of terre verte, Hooker's green and burnt umber applied with a small brush to darken the colours behind them. This helped to give more shape to the trees.

7 To suggest overhanging layers and create a contrast that highlighted the snow on those overhanging layers, I painted a little of this colour mixture at the very bottom of some of the middle-ground trees. This helped to anchor the trees to the ground.

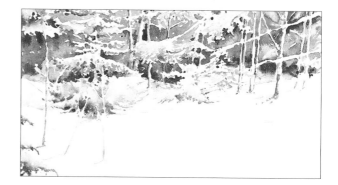

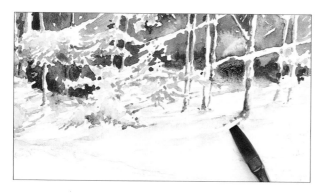

8 The shadow colour here was a very cool violet. I used a mixture of alizarin crimson and Winsor blue to create a very watery shadow colour, applying it to dry paper using a flat-headed brush, and pulling along the line of the shadow.

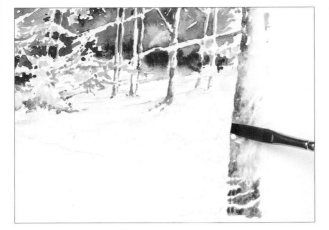

9 *I painted in the bark of the large tree using the flat-headed brush, pulling raw umber, burnt umber and cobalt blue around the shape of the trees. Painting on dry paper created broken brushstrokes as the brush was dragged across the textured paper.*

10 *Using a dabbing or dotting technique, I painted the small conifers beside the main tree trunk. The colours (Hooker's green, burnt umber and cobalt blue) were intensified to create a tonal distinction between the middle ground and foreground.*

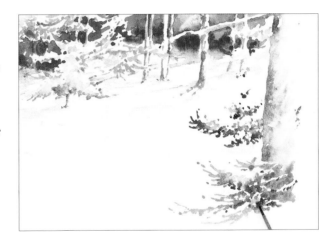

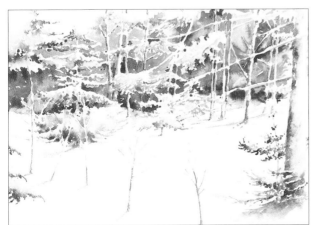

11 *To finish, I made a one-stroke application for the thin twigs in the immediate foreground. I used the mixture for the main tree trunks, pulling the colour upwards from the base to the top, and lifting the small brush quickly at the end of the stroke.*

CATCHING THE BALANCE

The colours used in this scene were chosen for their ability to complement the amount of white needed to represent the snow – too much subtlety could result in these tones being dominated by the highlights, while too strong colours would create too intense a feeling of light.

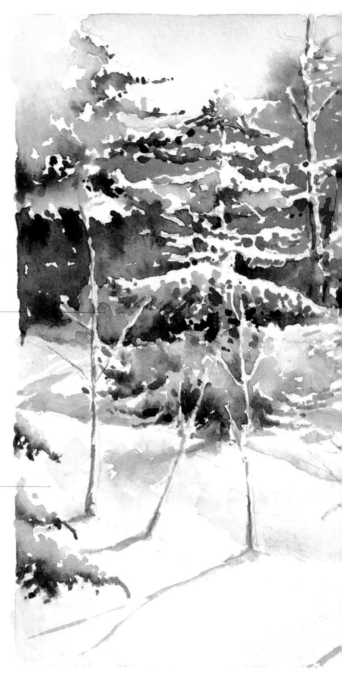

Among the many greens used in this scene, the deeper tones were used to create the feeling of depth in the background.

Broken brushstrokes allow the flashes of white snow to work for themselves.

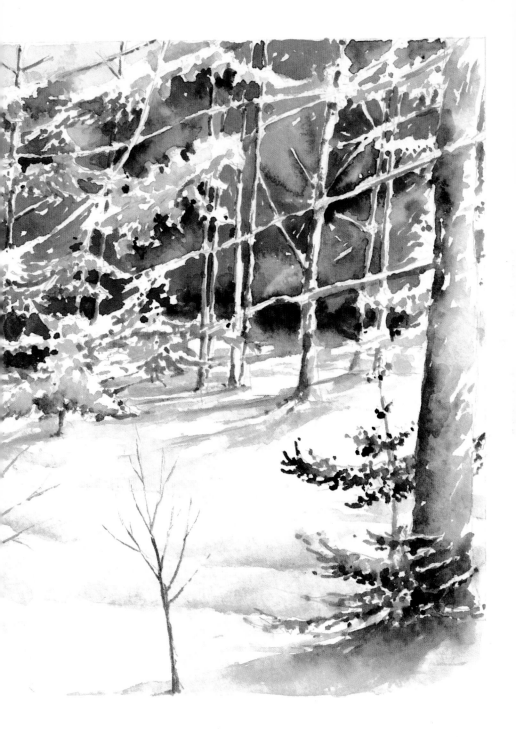

INDEX